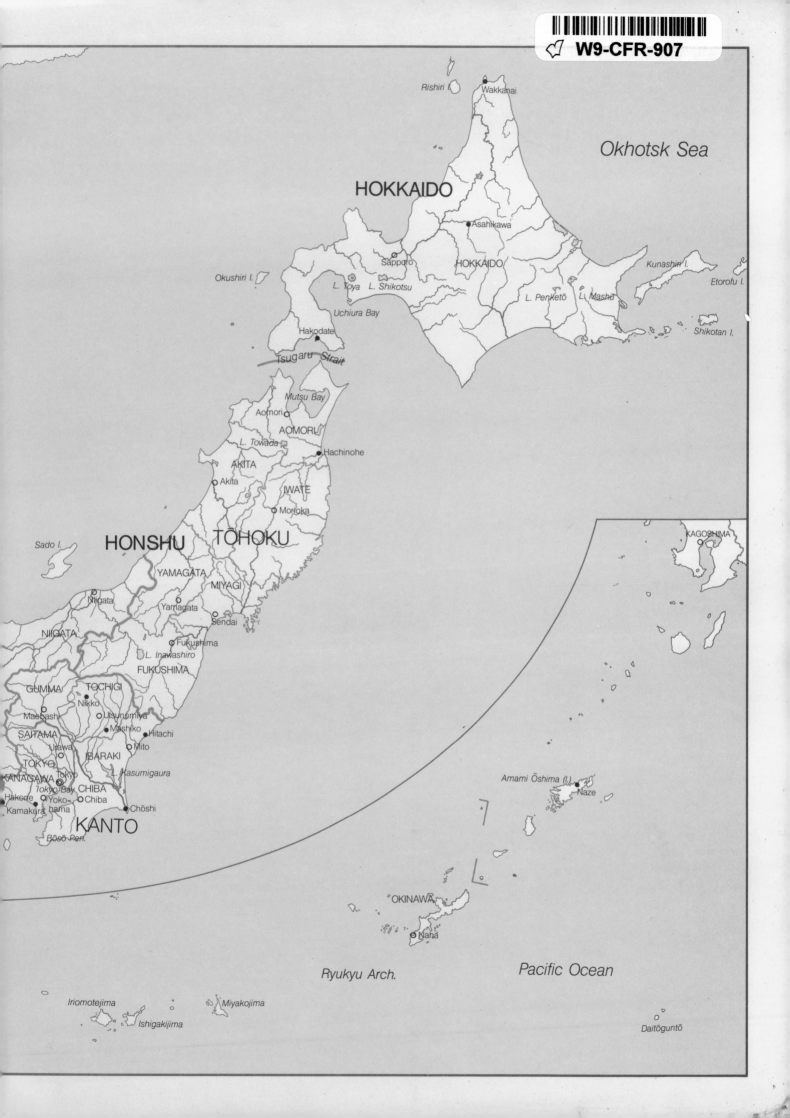

Okhotsk Sea

HOKKAIDO

Rishiri I.
Wakkanai

Asahikawa

Sapporo
HOKKAIDO

Kunashiri I.

Etorofu I.

Okushiri I.

L. Toya L. Shikotsu

L. Penketō L. Mashū

Uchiura Bay

Shikotan I.

Hakodate

Tsugaru Strait

Mutsu Bay

Aomori

AOMORI

L. Towada
Hachinohe

AKITA

Akita

IWATE

Morioka

HONSHU TŌHOKU

Sado I.

YAMAGATA

MIYAGI

Niigata

Yamagata

Sendai

NIIGATA

Fukushima

L. Inawashiro

FUKUSHIMA

GUMMA
TOCHIGI

Maebashi
Nikko
Utsunomiya

SAITAMA
Mashiko
Hitachi

Urawa
Mito

TOKYO
IBARAKI

L. Kasumigaura

KANAGAWA
Tokyo
CHIBA

Hakone
Tokyo Bay
Chiba

Yoko-
hama
Chōshi

Kamakura

KANTO

Bōsō Pen.

KAGOSHIMA

Amami Ōshima (I.)
Naze

OKINAWA

Naha

Ryukyu Arch.

Pacific Ocean

Iriomotejima
Miyakojima

Ishigakijima

Daitōguntō

INTRODUCING JAPAN

Revised Edition

Foreword by Edwin O. Reischauer

Text by Donald Richie

KODANSHA INTERNATIONAL
Tokyo • New York • London

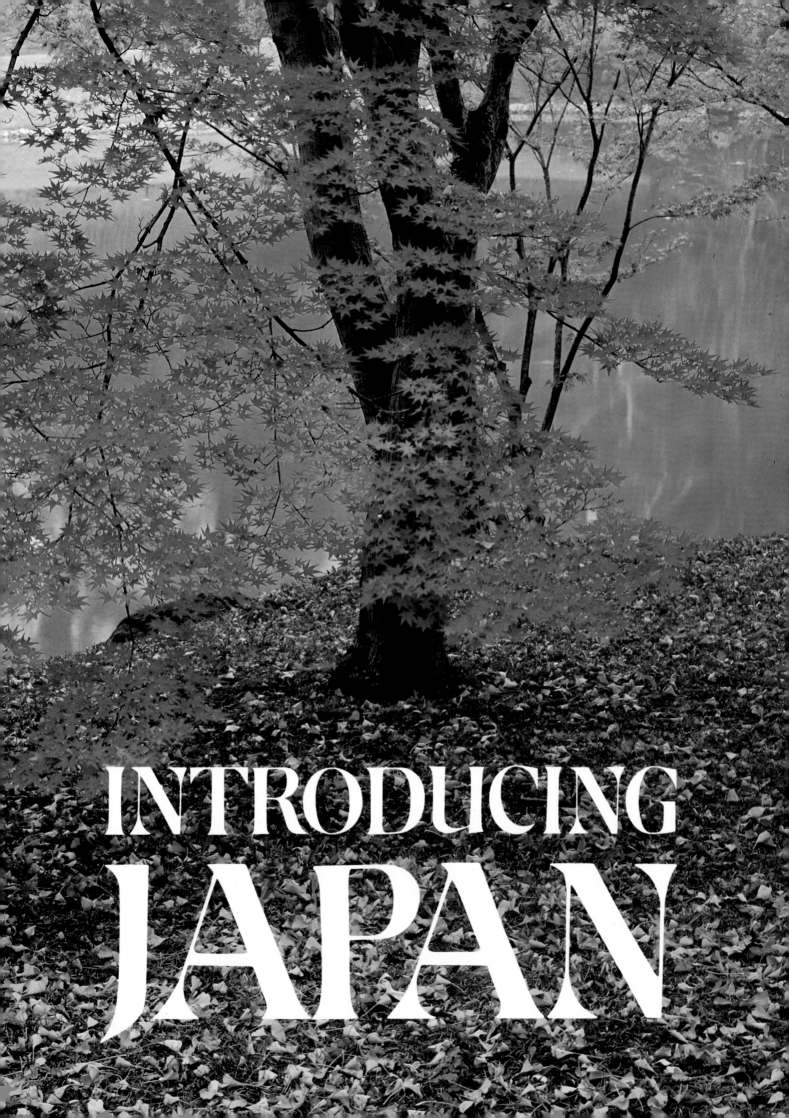

INTRODUCING
JAPAN

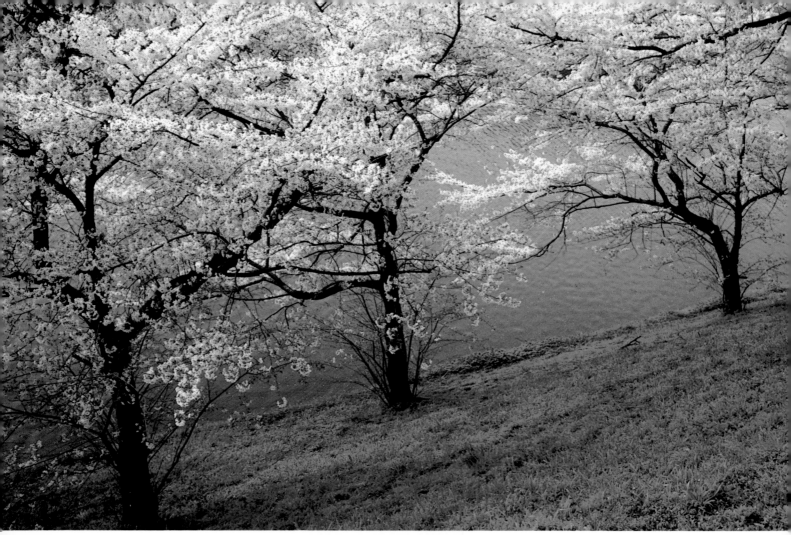

Photo credits: Minoru Akiyama, p. 67; Bon Color Photo Agency, p. 52 (bottom); Dandy Photo, p. 57 (top); Fine Photo, pp. 11, 13 (bottom), 23, 30 (bottom), 41, 52 (upper right), 57 (bottom); Hideo Fujimori, p. 10 (bottom); Tadahiko Hayashi, p. 47; International Photo Press Service, p. 25 (top); Gorō Iwaoka, p. 10 (top); Japan Karate Association, p. 72 (middle); Keizō Kaneko, pp. 9, 16, 17 (top), 18, 22, 28 (top), 31 (top), 33 (bottom), 46 (bottom), 70 (upper right); Junzō Kitao, p. 31 (bottom); Keisuke Kumagiri, pp. 17 (bottom), 71 (top); Nihon Sumō Kyōkai, p. 72 (bottom); Takeshi Nishikawa, title page, pp. 34–35, 36–37, 38 (top & bottom), 39, 58; Tōru Nogami, p. 12; PANA, p. 14 (bottom); © 1986, Walt Disney Productions, p. 15 (bottom); Ben Simmons, pp. 4, 13 (top), 14 (top), 15 (top), 21, 29, 30 (top).

Map on front endpapers by Michio Kojima.

Distributed in the United States by Kodansha America, Inc., 114 Fifth Avenue, New York, N.Y. 10011, and in the United Kingdom and continental Europe by Kodansha Europe Ltd., 95 Aldwych, London WC2B 4JF.

Published by Kodansha International Ltd., 17-14 Otowa 1-chome, Bunkyo-ku, Tokyo 112, and Kodansha America, Inc. Photographs copyright © 1986 by Kodansha International Ltd. Text copyright © 1978 by Kodansha International Ltd. Revised text copyright © 1990 by Kodansha International Ltd. All rights reserved. Printed in Japan.

LCC 77-75966
ISBN 4-7700-1791-X

First edition, 1978
Revised edition, 1986
Second revised edition, 1990
First paperback edition, 1994
94 95 96 5 4 3

CONTENTS

FOREWORD

Japan is a remarkable country and the Japanese an extraordinary people. Their lifestyles are a fascinating blend of ancient traditions with the most advanced technologies and modes of contemporary urban life. Their land is small but varied and beautiful. Man and nature have conspired to make it a visual wonderland. On the one hand there are rugged mountains, majestic coastlines and a rich pervading verdure. But mixed with these are the neat and pleasing patterns of a gardenlike agriculture, the stately monuments of a rich cultural past and the dynamic sprawl of a vigorous industrial society.

Although nature has left Japan poor in resources and ill provided with land suitable for either cities or agriculture, it has endowed it with rich scenic beauty. Great ranges of mountains or seas of broken hills cover most of the land. Peerless Fuji rises directly from the ocean to 12,389 feet. The land is broken into four main islands and thousands more of lesser size. Everywhere rugged hills plunge down to the sea, where the agelong battle of waves against rock has created its own grand sculpture. Plentiful rainfall makes the whole country a wondrous green, while thousands of years of loving cultivation of the soil have given it a soft, man-made patina.

But however beautiful Japan may be, it is the achievements of its people that have made it so outstanding. They have had a remarkable history, off in their isolated islands on the eastern fringes of what was once the known world. An agricultural civilization possessing both bronze and iron began to spread into these islands from the nearby continent well over two thousand years ago and by the sixth century had produced a more or less unified state covering the western two-thirds of the land.

Then an extraordinary change took place. Between the seventh and ninth centuries the Japanese made an amazingly ambitious effort to adopt all of the advanced institutions and arts of China, which at the time was probably the leading nation in the world. One result was to make Japan a truly unified country—probably next to China the second oldest of all existing nations to attain its present shape with the same people and language it has today. Another result was the borrowing of the Chinese writing system, an extraordinarily difficult system most ill suited to Japan's very different type of language. But it brought with it a highly developed aesthetic of its own and a huge and rich literature, both of which have had profound influence on Japanese culture ever since. The Japanese also mastered the Chinese arts. The seventh- and eighth-century Buddhist monasteries which remain from that age are not only the oldest wooden buildings in the world but perhaps the most beautiful. They are also crammed with great sculptures and other works of art from that distant time.

Japan, however, remained a remote land, in that age of primitive seamanship, and the cultural bases for the Chinese-type superstructure the Japanese had created were quite different from those of China. Just as Northern Europe, with its own tribal background, diverged in medieval times from the classic patterns of Greece and Rome, Japan from the eleventh century on diverged into a feudal pattern not unlike that of Europe. The canons and skills of Chinese art remained and were refreshed from time to time by further contacts with the continent, but the society and the political system became entirely different. As in Europe, feudalism went through a series of stages, each leaving its own distinctive artistic heritage—the great Buddhist sculptures and paintings of a fervent age of faith in early feudal times; the simple but sophisticated gardens, which flourished a little later under Zen inspiration; the soaring walls, brooding moats and airy white towers of the castles built around the beginning of the seventeenth century; and the ornate mausolea at Nikko of the Tokugawa shoguns, who were the feudal overlords of the time.

Starting in the sixteenth century, Japan had a period of exuberant relations with the West as well as neighboring Asia, but the feudal rulers then cut off these contacts in the early seventeenth century and plunged the nation into deep isolation from the rest of the world. During the next two centuries the Japanese had the opportunity to cultivate their own cultural heritage at leisure, developing it perhaps into the most distinctive higher culture in the whole world. But an isolated Japan also fell technologically far behind the West. When in 1853 Commodore Perry of the American navy knocked sharply on Japan's closed doors, the Japanese were forced to open up, but they faced a fearsome prospect. However refined their arts and sophisticated their institutions might be, Japan was not able to compete with either Western military or economic technology. Far larger and apparently stronger Asian lands, such as India and China, had already been forced to bow to Western rule, or at least to semi-colonial domination.

That was only a century and a half ago, but Japan's history since then has certainly been the most remarkable in the world and in many ways the most significant. Within fifteen years of Perry's arrival, an ambitious group of young Japanese carried out the so-called Meiji Restoration, sweeping away the feudal system and creating a more centralized nation around the symbolic figure of the emperor, who ever since remote antiquity had been the theoretical source of authority and legitimate rule. They proceeded to make their people an educated nation, to import and master the technology of the West, and to enter into international trade and political life. By giant strides Japan became a more modernized country, its industry became competitive with that of the West, and the nation gained in strength both as an economic and military power.

The course was not all smooth. Rapid change made for painful economic and social dislocations and nagging psychological doubts. Wars were fought that severely strained the nation. In fact, for a while Japan followed a disastrous course, seeking to establish hegemony over all East Asia at a time when changing military technology and rising worldwide nationalism made overseas empires no longer possible to build or even to hold on to. The result was the catastrophe of World War II, which left the Japanese all but destitute and forced to start all over again in an attempt to catch up with the West.

The story since then has often been called the Japanese "miracle," and miraculous it may seem when one looks at the results. Not much more than a century ago Japan was a small, isolated land, standing outside the main currents of world trade and politics. Less than a half century ago it lay largely destroyed and seemingly incapable of supporting its burgeoning population on its meager resources. Today in economic power it stands

ahead of the once great powers of Western Europe and the great continental colossus of the Soviet Union. Only the United States, which has twice its population and twenty-five times its geographic size, stands ahead of it.

The so-called economic miracle, however, is not what is most remarkable about Japan. Two other features of Japanese life seem to be even more noteworthy. One is the way the Japanese have kept alive and actually breathed new vigor into their traditional culture—its arts, music, drama, literature and ways of life—while at the same time deeply imbibing the cultures of the outside world and sharing with other modern industrialized societies what might be called the contemporary international style of life.

The other feature is the political and social changes that have accompanied economic modernization. These have transformed Japan from a tightly organized, highly aristocratic, feudal society only a little over a century ago into a remarkably stable but extraordinarily free, egalitarian and democratic society today. The people are basically contented and happy. Crime is far lower than in most urbanized countries. Though the land is intensely crowded, everything operates briskly and without confusion. Society is stable and moves along smoothly. The democratic political system, while operating in many ways quite differently from our own, produces the necessary decisions and efficiently provides the services it should. All in all, it would be hard to find any large country in our contemporary world that runs more efficiently, smoothly, fairly and openly than Japan.

All this puts Japan in a unique position in the contemporary world. The most significant fact about Japan is that it is the only major non-Western country that has become a thoroughly industrialized and modernized democracy. Drawing on a different cultural heritage from our own, it has developed a pattern of modernization quite distinctive from those of the industrialized countries of the West. Since Japan at the same time is handling many of the problems of urban industrial society with greater success than are the countries of the West, there may be much for the West to learn from Japan in economic, social and even political skills, just as the West has already begun to learn much from Japan's rich artistic, philosophic and literary traditions.

More important may be the role Japan can play for the other non-Western nations, which constitute the bulk of humanity. As the only major non-Western nation which has modernized its technology, institutions and patterns of life, Japan naturally serves as an inspiration to the others, which would like to do the same but often find the task difficult. Japan's affluence and its ordered but free society can serve as a beacon to these lands. The continued strength of Japan's traditional culture also holds out the promise to these other peoples that modernization need not rob them of their cultural identity.

Japan's position in the future world may be even more significant than its position today. The greatest problem facing mankind during the next few generations may well lie in the vast chasm that is opening up between the rich industrialized nations and the poor pre-industrial or semi-industrialized lands. This economic division is made all the wider by the fact that all of the rich countries, save Japan, are of the white race and have a Western cultural background, while the others are mostly non-white and non-Western. Only Japan clearly straddles this great gulf—affluent, highly industrialized and thoroughly modernized on the one hand, but obviously non-white and non-Western on the other. This is a unique position and one that may give the Japanese a most significant role to play if this dangerous chasm is ever to be closed. Their ability to develop the skills and willingness to play this role could prove crucial for the world's future.

Edwin O. Reischauer

TOKYO

Tokyo, the capital and the largest city in Japan and perhaps in the world, is an enormous metropolis holding more than one-tenth of the country's entire population. Over half of the major corporations of Japan have headquarters here, most banks have Tokyo head offices, and the city's more than two hundred colleges and universities educate over half of all the students in the country. It is the busiest city in a notoriously busy country and one's first impression is one of constant activity, much of which seems to be expended in tearing down and rebuilding the city itself.

Tokyo has been in the throes of this building boom for the last four centuries, and its face is continually changing. Buildings come down and go up at a pace unmatched in other cities of the world; six months' absence from a major Tokyo district is sometimes enough to render it virtually unrecognizable. Though the city has been flattened on several occasions (most recently during the 1923 earthquake and the 1945 wartime bombings), it always patches itself together and always grows larger and larger.

Greater Tokyo is now comprised of twenty-three wards, twenty-six cities, six towns and nine villages, some of the latter on the distant Seven Isles of Izu and the Ogasawara Islands, which are also under the jurisdiction of the metropolis.

The city has also grown progressively vital. It is this tremendous vitality, this enormous energy, that makes Tokyo, not a city noted for its outward beauty, a nice, or at least an exciting, place to live. The disappointed first-time visitor may feel that with its clutter, its superhighways, its noise, it resembles, say, Los Angeles. Before the week is out, however, the reassured visitor realizes that, despite any superficial resemblance, this city of eight hundred and twenty-seven square miles and thirteen million people does not act or feel like any other city in the world.

Edo Castle with its moats and its fortifications was the residence of the Tokugawa rulers for two hundred sixty-five years and, after 1868, the residence of Japan's emperors. It still is, though the new Imperial Palace dates from 1968.

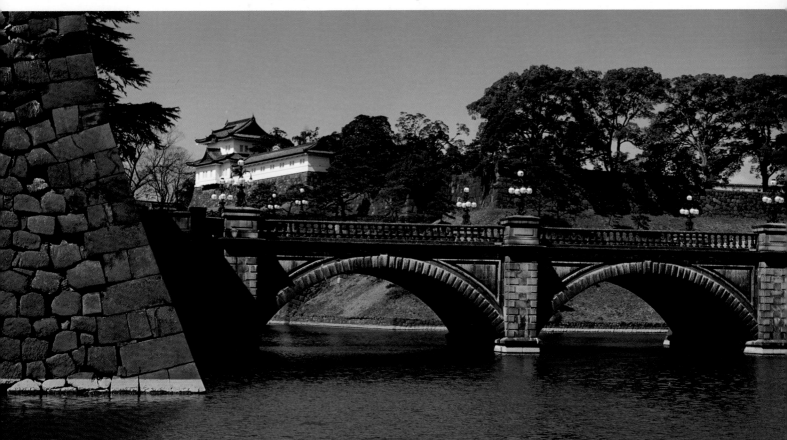

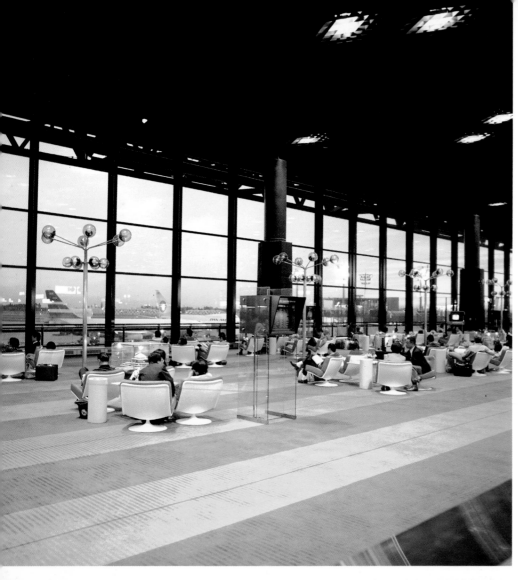

The first of Japan encountered by the visitor is the New Tokyo International Airport (*left*), a huge complex of tarmac, plane piers, shops, restaurants and waiting lounges. Here the visitor is prepared for the extreme modernity which Japan as a whole also offers—that urban melange of contemporary architectural styles, which initially makes the visitor despair of seeing anything "Japanese." The modern structures of Tokyo, Osaka and other cities are now, however, just as Japanese as is the occasional thatch-roofed farmhouse.

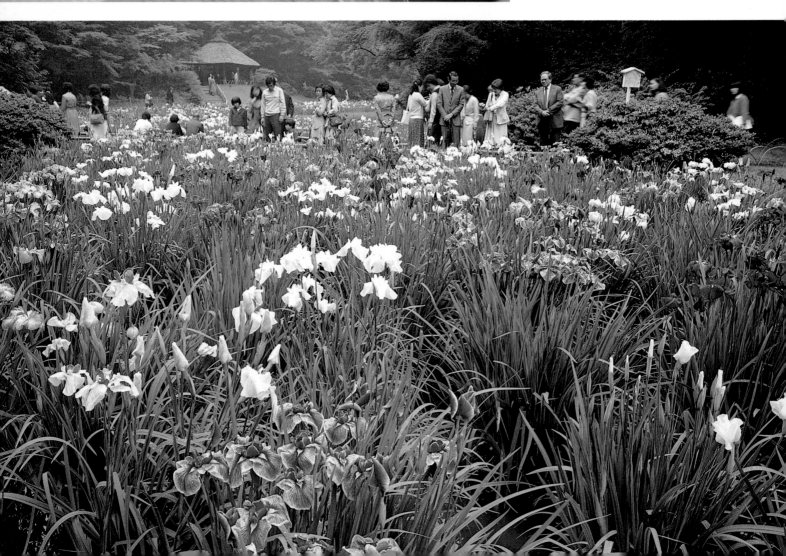

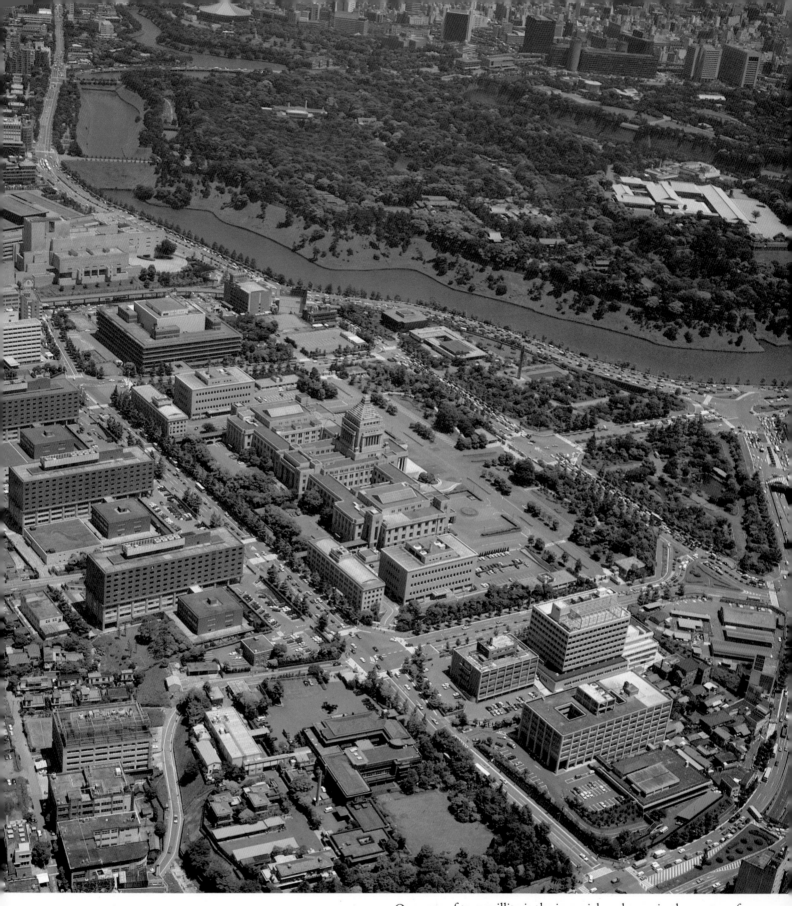

Despite the high price of land, Tokyo itself still shows remains of natural beauty, though these are fewer than in most major cities. Perhaps the rarity accounts for the popularity. The celebrated viewing spots (such as, during June, the iris garden in the grounds of the Meiji Shrine, *left*) are always filled with crowds.

One area of tranquillity is the imperial enclosure in the center of the city (top of picture above), which the public may enter at New Year's and on the emperor's birthday. Nearby is the Diet Building, the seat of the legislature (bottom of the picture above). In the left half of the building is the House of Representatives and in the right, the House of Councillors.

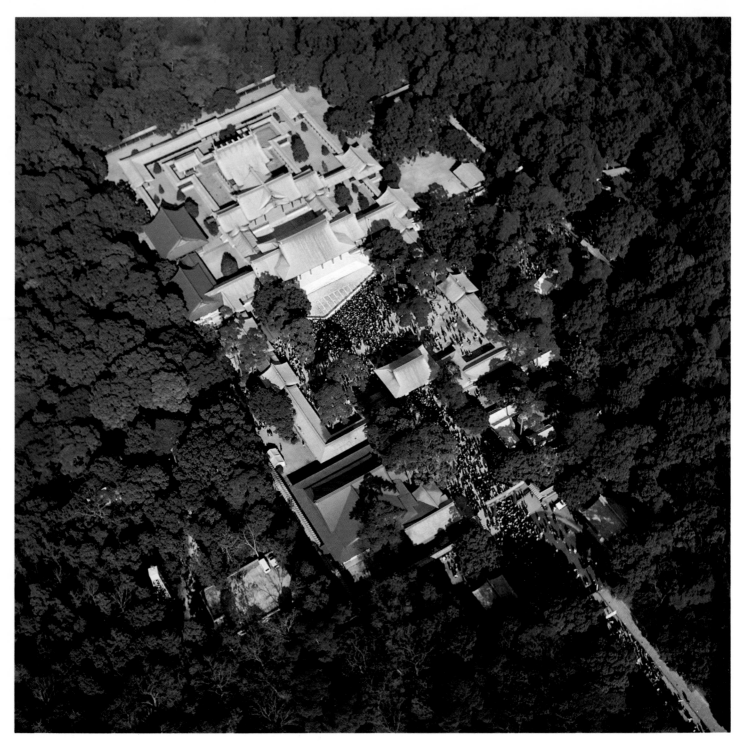

The quietest section of the whole city and, though only completed in 1920, one of the most traditional is the Meiji Shrine, a Shinto complex set in a cypress forest and dedicated to the Emperor Meiji (r. 1867–1912). Here on New Year's day (*above*) over a million people come to pay their respects, to pray for a good future, to savor the tranquillity of the forest and the beauty of the gardens, and to enjoy a respite from the city's pace.

Elsewhere, man-made modernity takes over—nowhere more so than in Shinjuku (*right*), an area dramatically contrasting with the nearby Meiji Shrine. It is the most popular amusement center and one of the largest night-cities in the world. Here are bars—thousands of them—cabarets, clubs, restaurants, theaters and coffee shops, a whole city within a city served by the most crowded railway station in the whole country. Here too is the most spectacular aspect of modern Tokyo, a group of recently (since 1971) constructed skyscrapers, shown here as seen from the confines of the nearby Shinjuku Outer Gardens.

Tokyo is perhaps best seen as the metropolis it is when the sun goes down and the lights come on. Tokyo Tower, brilliantly illuminated (*right*), stands out against the evening sky as the lights of Tokyo extend in all directions.

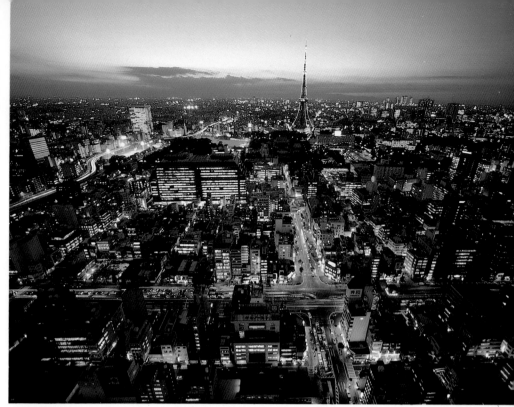

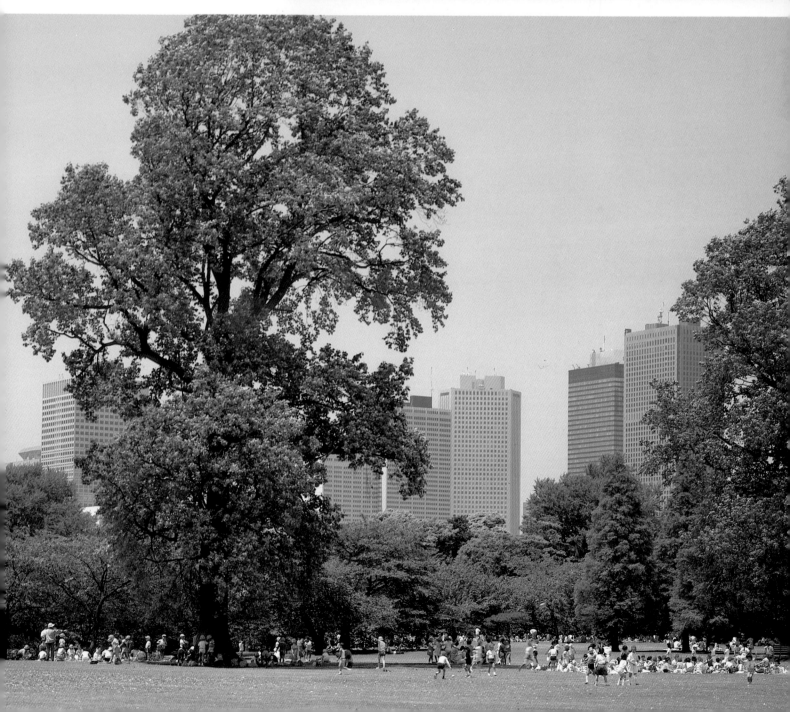

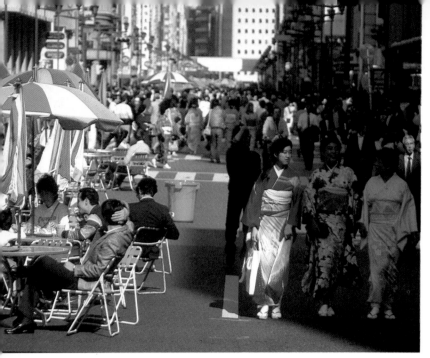

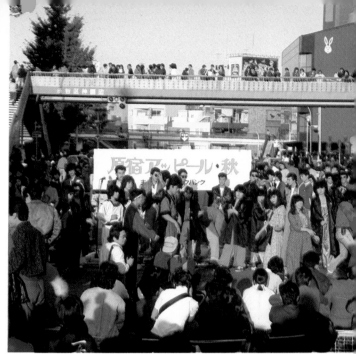

The contrast between old and new continues even in modern Tokyo. On Sundays on the Ginza, for example, one still sees an occasional kimono (*above left*). More common is the newest of the new as seen every Sunday in Harajuku (*above right*), where young people gather to dance and show off. Tokyo is, among other things, a "fun" city, one filled with amusements. Among these are sports and, in particular, baseball (*below*). At the enormous all-weather Tokyo Dome thousands come to enjoy what has been called Japan's "real" national sport.

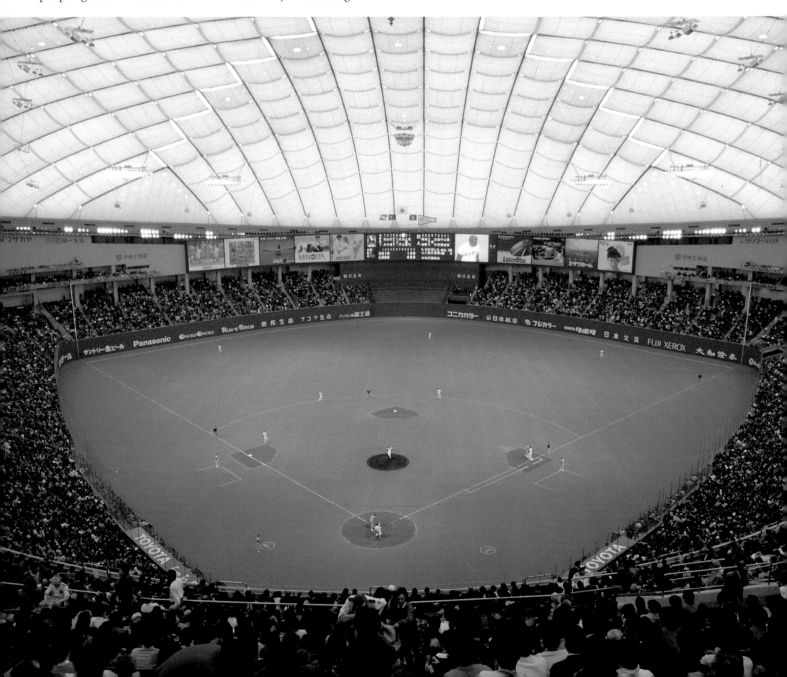

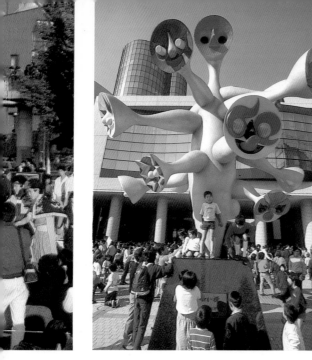

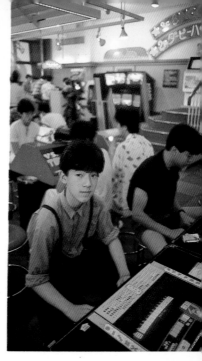

Among the many amusement centers is the Kodomo no Shiro (*above left*), the Children's Castle, in Aoyama. Feeding the young are numbers of fast-food outlets including several well-known in other countries (*above center*). And, as in most countries, the young in Japan are much involved in computerized entertainment, as in this game center (*above right*). Tokyo even has its own Disneyland (*below*), similar to the famous Californian original. There too flock the Japanese young—and their mothers and fathers and grandparents.

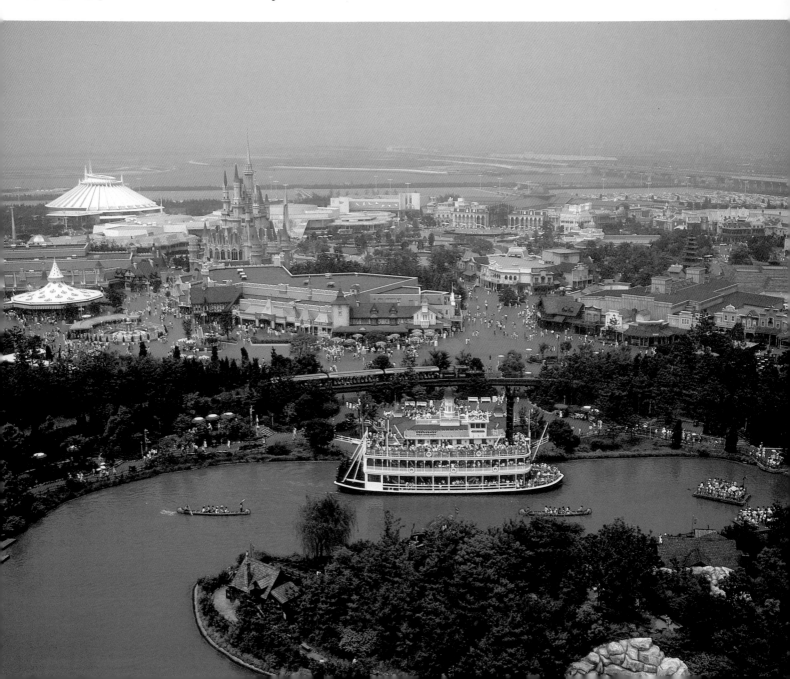

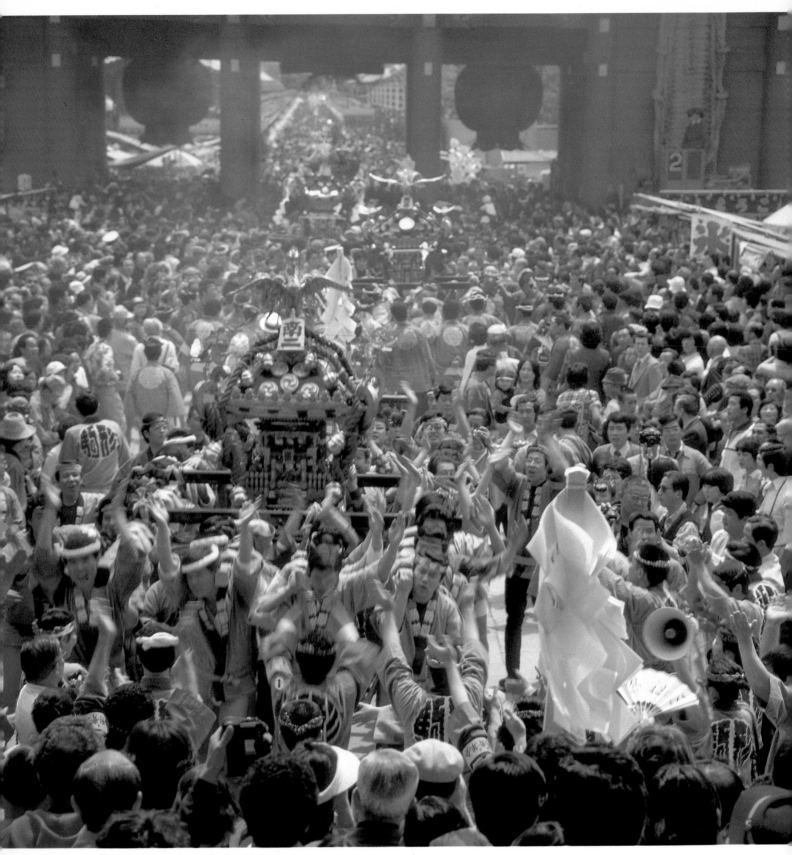

At the same time, amid the modernity, traditional Tokyo still exists, if you know where to look for it. One of the places is Asakusa, located in the old *shitamachi* or downtown district by the Sumida River. Here toward the end of May is still held the traditional Sanja Festival, a colorful Shinto rite in which the god (inside the portable shrine) is carried in boisterous state about the district, a reminder of the old days when Tokyo was still called Edo.

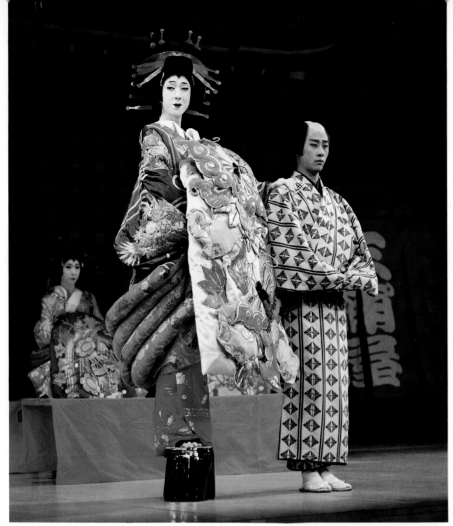

Among the traditional Edo entertainments still being performed is the Kabuki. This classic theater traces its beginnings from the seventeenth century and is now world famous because of its pageantry and color, and because, like so many traditional Japanese arts, it has remained relatively unchanged over the centuries. Here (*left*) is Bando Tamasaburo, the most popular of the younger actors specializing in female roles, in the opening scene (the procession of the *oiran*, predecessors of the geisha) from the Kabuki play *Sukeroku*.

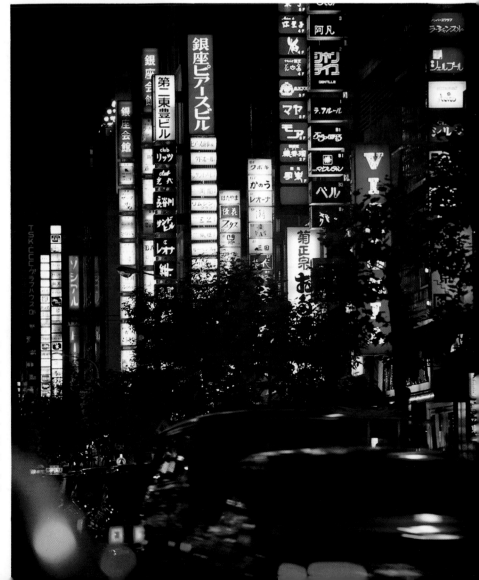

The opposite of the old, traditional, Edo-like *shitamachi* is the modern, outwardly Western uptown, the *yamanote*, where the contemporary is not only visible but inescapable. It is the other pole of Tokyo, an area of bright lights and foreign trimmings, which counterbalances that of continuity and tradition. Both are equally important; it is perhaps through this equilibrium that the whole enormous city, and the country itself, manages to be progressive and at the same time retain elements of its past.

NIKKO

Nikko is an enormous national park, one of twenty-seven and the most popular. Less than two hours by train from the capital, here the Tokyoite finds the nearest natural beauty—an area filled with mountains, lakes and forests. A well-known summer retreat, playing the Catskills to Tokyo's New York, it contains campers, climbers, swimmers, anglers, and great cool groves of cedar.

In the midst of the cedar is the other attraction, the Toshogu shrine and the Nikko Mausolea. These gorgeous, ornate, indeed overwrought, buildings, perfectly situated in their incomparable forest, look like small jewels among the trunks of the giant trees. Amid all the carvings are found such favorites as "the sleeping cat" and the world-famous simian trio with their hands over ears, mouth and eyes, respectively referred to as "Hear no Evil, Speak no Evil, See no Evil."

Though Japan is famous for rearranging nature, the Japanese were almost equally impressed by nature untouched. There was a romantic, almost Teutonic, regard for solitary mountains, lonely forests and deserted plains (such as Odashirogahara, *below*). Though these are admittedly hard to find in overcrowded Japan, the mystique and the attraction of nature unspoiled lingers.

Henry Adams and other early travelers came to gaze upon this gorgeously overdecorated entrance to the seventeenth-century mausoleum (*right*) of Tokugawa Ieyasu, the first of the Tokugawa shoguns, and were much impressed when told that it required over two million sheets of gold leaf and that if all its timbers were laid end to end, the result would reach from Edo to Kyoto.

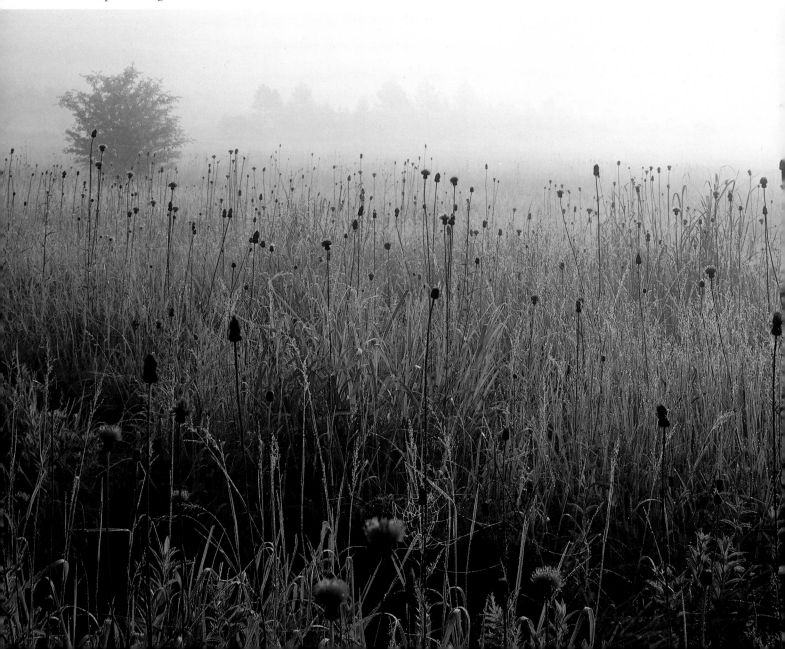

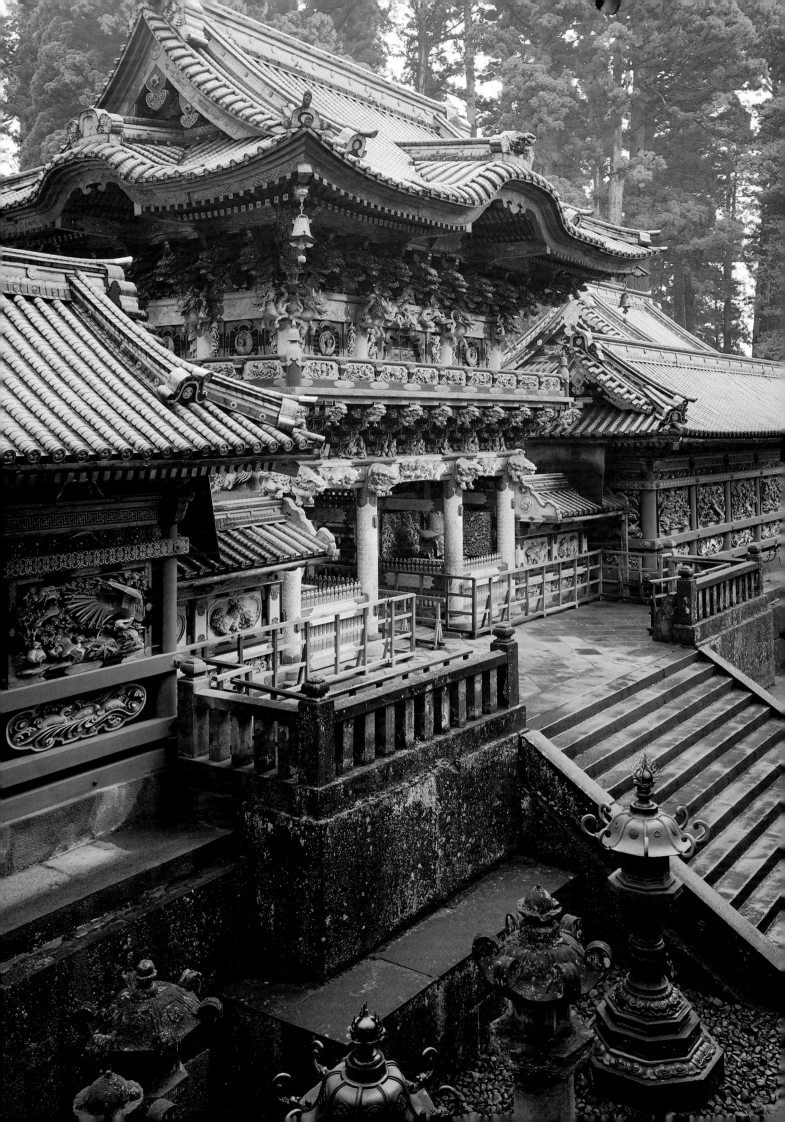

KAMAKURA

Kamakura, south of Tokyo, remains a center of historical and holiday interest. After the eclipse of imperial power, centered in Kyoto, Minamoto Yoritomo (1147–99) built his stronghold here, facing the sea and backed on three sides by mountains. This small provincial town became the capital of the shogunal government which survived until 1333. There are many reminders of these stern and austere times, including the Tsurugaoka Hachimangu shrine, built in 1191 (the present buildings date from 1828) and its famous ginkgo tree, which is presumably as ancient.

In main, however, the places of interest are connected with Zen Buddhism, since it was this sect that found favor with the military. Among the best of these, known as the five great Zen temples of Kamakura (imitating an equally great five in Chinese Zen literature), are the Kenchoji, Engakuji, Jochiji, Jufukuji and Jomyoji. All are still active, with priests in residence and laymen, both novices and adepts. Jochiji has an early Kamakura-period Jizo, guardian deity of children; Engakuji has a "tooth of the Buddha" and the largest bell in Kamakura. These temples and many others are spread around the city, often right next to the parking lot or the villa, the supermarket or the Museum of Modern Art, for Kamakura has also become a Tokyo commuter's suburb.

Among the most beautiful of Kamakura's temples is Kenchoji. It was founded by one of the military regents in 1253 to accommodate the Chinese priest Rankei Doryu, who, like many of his brethren, came to these distant islands to spread Zen Buddhism. This temple is the headquarters of the Kenchoji branch of the Rinzai sect, and though some of its original buildings were destroyed by fire, the grave of Doryu, who is revered as Daikaku Zenji, is still there.

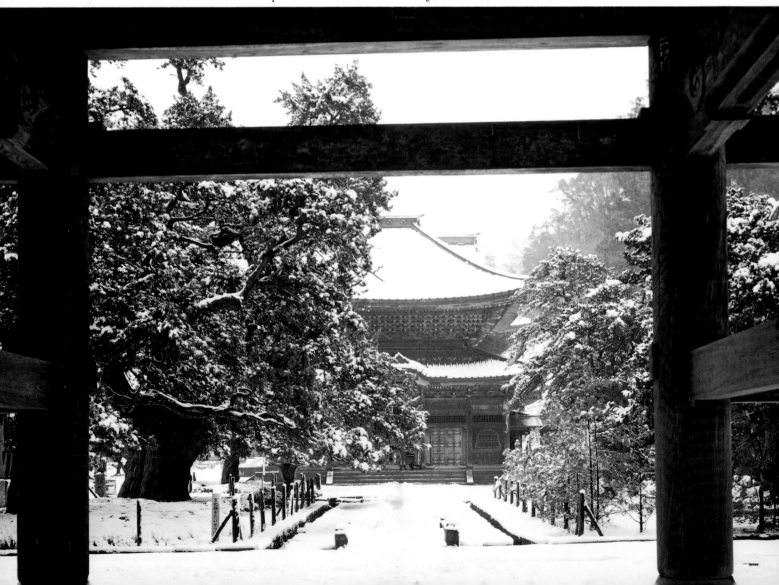

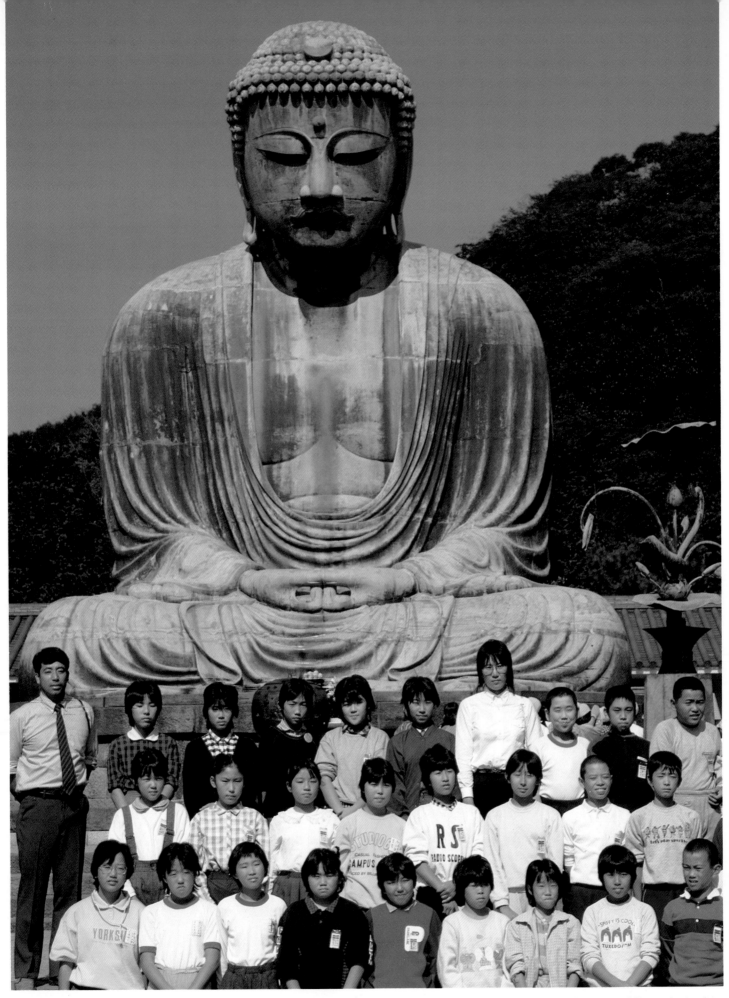

The most famous sight in Kamakura is, of course, the great statue of the Buddha, the Kamakura Daibutsu, a bronze figure said to have been cast in 1252 and now, for many, synonymous with Japan itself. Though not as old as the much larger Buddha at the Todaiji in Nara, it is considered by far the more beautiful.

MOUNT FUJI AND HAKONE

Hakone is the hot-springs area nearest Tokyo, about two hours away by train. Scattered about in the mountains are the famous Twelve Spas of Hakone, the oldest of which is Yumoto and the most popular of which is probably Miyanoshita. The area lies in the crater of what must have been an enormous volcano—hence all the hot water—which no doubt rivaled and perhaps dwarfed the immaculate Mount Fuji, located right next door, as it were, to this resort area. The inland post road connecting Edo and Kyoto ran through these mountains, and the Hakone Barrier is mentioned often in poetry and drama. The journey between the two cities, on foot or by palanquin, used to require ten days.

Mount Fuji has become emblematic of Japan, the single sight everyone knows, even without actually having seen it. Its perfection has long been celebrated in prose and in painting, in poetry and in woodblock prints. Among the many celebrated views is the one from Lake Kawaguchi (*below*), showing the spring aspect of Fuji with willows and cherry blossoms.

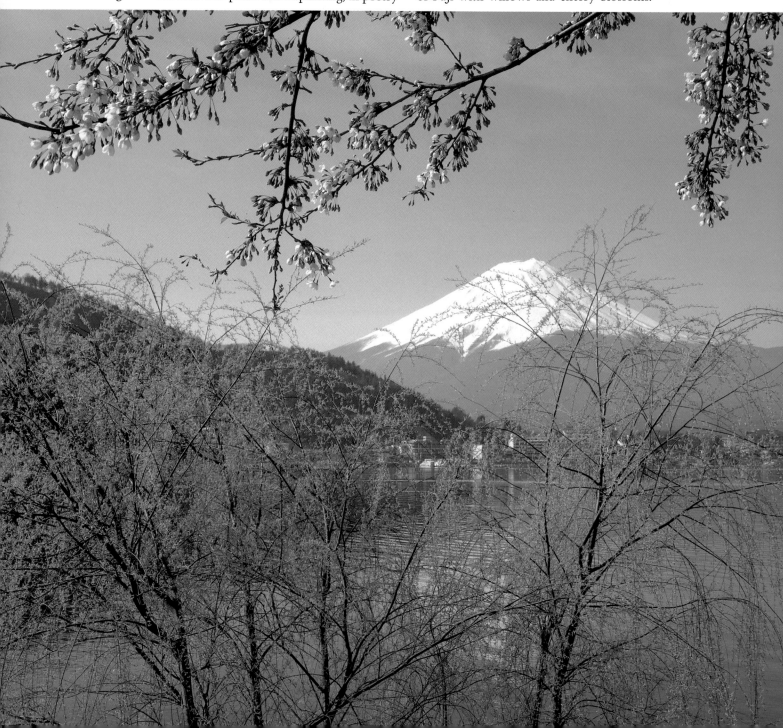

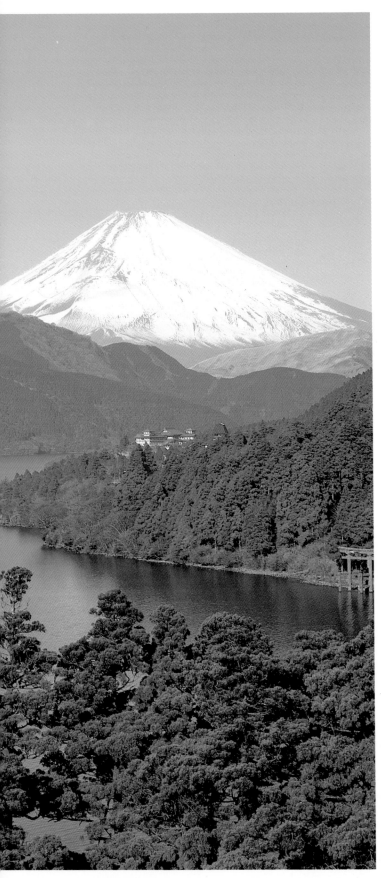

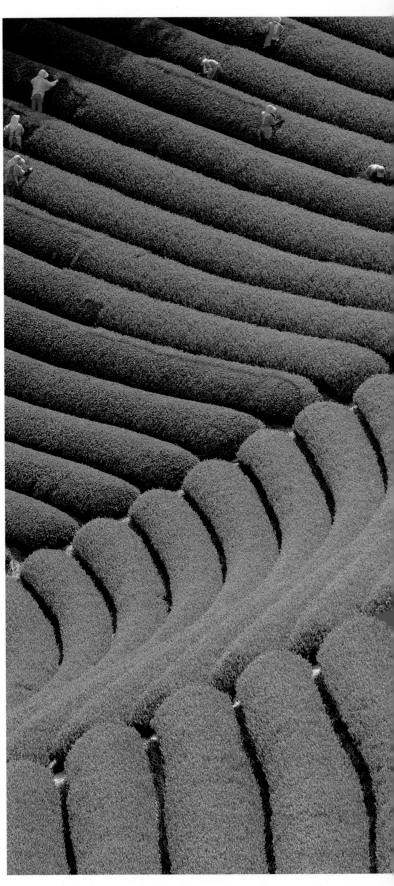

During the cold, clear days of autumn, glimpses of snow-capped Mount Fuji can be caught from as far as a hundred miles away. It was, at least until quite recent times, considered to be sacred. Now firmly secular, the mountain is yearly scaled by more than three hundred thousand litter-prone climbers, who discover that, though the view from the top is magnificent, the mountain itself, a pile of volcanic debris, is best viewed from afar, as seen here (*above left*) from Lake Ashi. To the south of Fuji lie the plains of Shizuoka. Warm, even during the winter, this clement region produces the *mikan* (autumn tangerines), large spring strawberries, and (*above right*) terraced acres of green tea, once used only medicinally, now the national beverage.

THE CHUBU DISTRICT

Honshu, the main island, is divided into five districts. Among these is the Chubu, which, as the name implies, is right in the middle. It is also referred to as the "rice bucket" of the country, because here where the island is at its widest are found some of the best farmlands. These are given over largely to crops of rice, Japan's staple grain.

In this district, too, encroaching on the farmlands, are some of the country's highest mountains and, on the shores, slowly squeezing out the paddies, is some of the heaviest of Japan's heavy industry. The industrial capital of the area is Nagoya, which had its beginnings as a city around 1610 when Tokugawa Ieyasu built a castle for his son Yoshinao. The castle remains—reconstructed in 1959, with an elevator—and is now surrounded by indisputable evidence that Japan is indeed one of the leading industrial nations of the world.

Running down the center of Honshu are three relatively short but high mountain ranges known as the Japan Alps, a term first coined in 1881 by an Englishman but now, like so many other words, adopted into the Japanese language. Perhaps the most spectacular range is the northern one, the Hida, and among the most typical of its peaks are those of Tsurugidake (*below*), with its jagged ridges and its sudden gorges. Here, in the country of the transistor and the pocket calculator, live the antelope, the ptarmigan and a multitude of alpine plants.

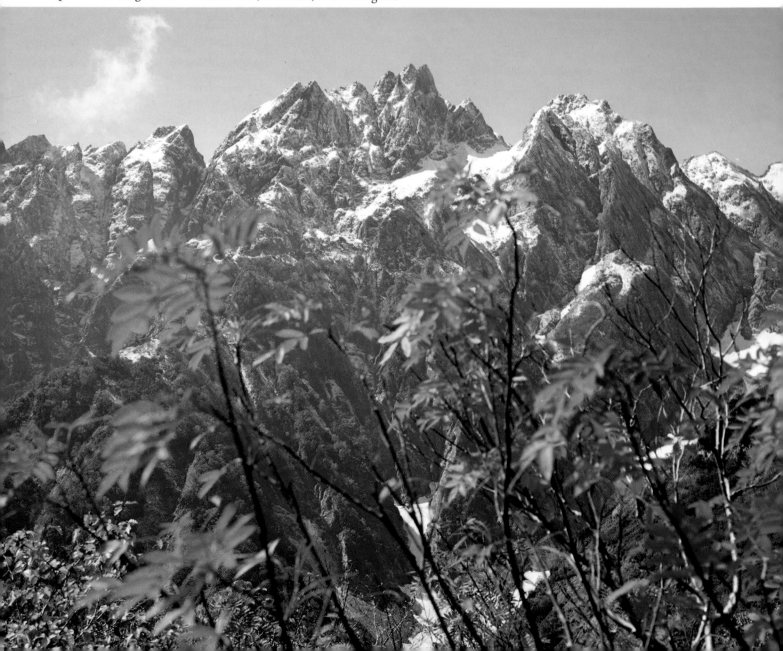

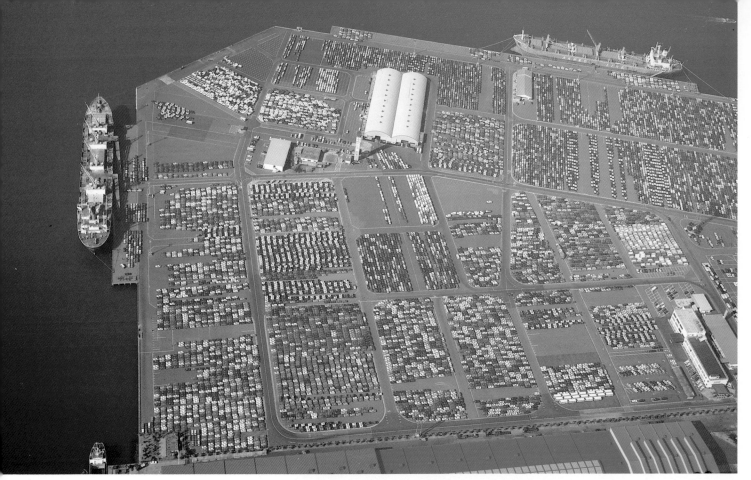

In this central district, where the largest island is both highest and broadest, is located Japan's fourth largest city, Nagoya, sometimes referred to as Chukyo, or the Middle Capital, because it is situated between Tokyo and Kyoto. It is a noted pottery and porcelain center (92 percent of Japan's exported chinaware comes from here), but more recently it has become a home for heavy industries, such as shipbuilding, automobile manufacturing and shipping.

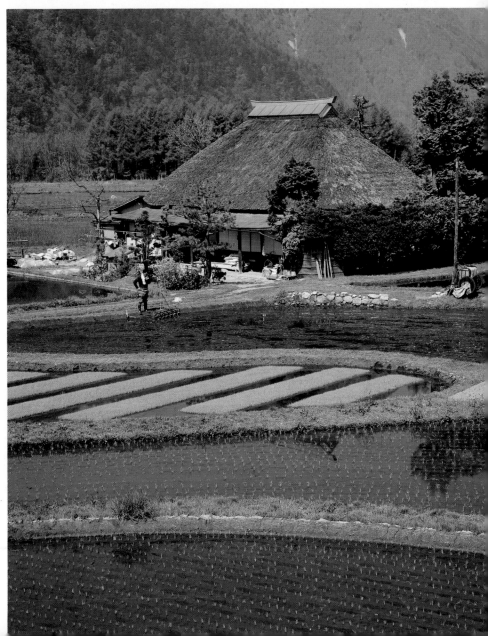

In the farmlands of this Chubu district, though the sight is increasingly rare, one still finds the old-fashioned farmhouse with its thatched roof and doors of paper-covered frames. Nowadays it is also surmounted by a television antenna and has a carport as well. The surrounding paddy fields, however, are much as they always have been during centuries of continuous cultivation. Rice was eaten by a majority of Japanese three times a day, and much of the arable land is still devoted to it.

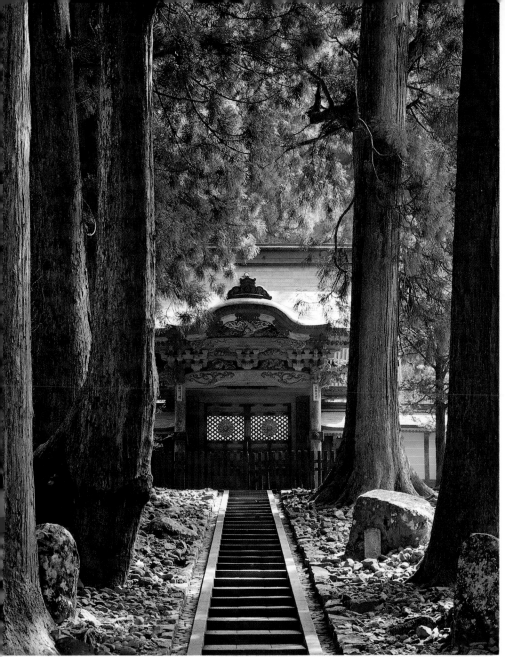

Japan's central district is typical, too, in the number of past remnants still existing and still in active use. One such would be the thirteenth-century temple of Eiheiji (*left*), which prospers to this day near the city of Fukui on the Japan Sea coast. One of the two headquarters of the Soto sect of Zen Buddhism, it remains an important theological center, and its meditation hall is always filled with novices and disciples, both Japanese and foreign. During their stay, the Zen students lead a spartan life and eat frugally; a typical meal consists of rice gruel, clear soup and pickled vegetables, served simply (*above*).

Another reminder of the past is the *ukai* or cormorant fishing, which can be seen, largely for the benefit of tourists, on the Nagara River at Gifu, near Nagoya. Of very ancient origin (nocturnal cormorant fishing is mentioned in the *Kojiki*, a historical record completed in 712), it is practiced in very near its original form. The birds are controlled by leashes, which also prevent them from swallowing their catch of troutlike *ayu*. This is taken from them, cooked on the spot, and served to the assembled guests.

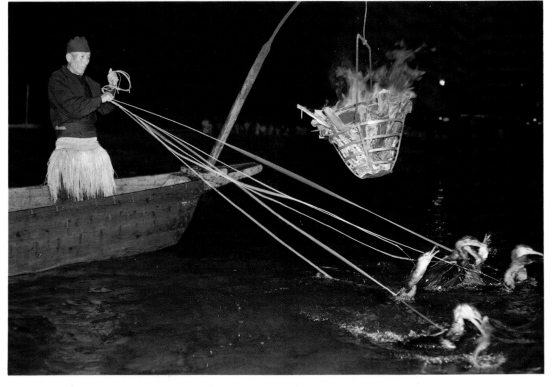

THE KII PENINSULA

The Ise-Shima National Park is a picturesquely indented tongue of land below Nagoya, an eastward extension of the great Kii Peninsula southeast of Osaka and Nara. Here the land is old and rich in historical associations going back to mythological times. The sacred mountains and forests of Kumano are not far away, and Nachi Falls, celebrated in art and literature, is just at the end of an hour's train ride. Nearby too are the blossoming cherry groves of Yoshino, numbering over a hundred thousand trees, all of which come into bloom in April.

Also within the national park are the magnificent Ise Jingu shrines. There are two of them, the Geku, or Outer Shrine, and the Naiku (Kotai-jingu), the Inner Shrine. These Shinto shrines, the most venerated in Japan, are set in groves of cedar, some of them half a millennium old. Here the atmosphere is one of peace, calm and benevolence. The visitor to the Inner Shrine crosses the Uji Bridge, enters under the first *torii* (gate), stops to wash the hands and rinse the mouth in the waters of the Isuzu River, then proceeds to the shrine. This is sacred ground, yet at the same time it is supremely natural and invitingly human. Here Shinto, the original religion of Japan, prevails with its quiet acceptance of all nature, including human nature.

The Ise Shrines are made of unpainted cypress constructed in the pure *shimmei* style of architecture native to Japan. Each holds its massive *kaya* roof of cut reeds, and no nails or screws are used in the construction, each piece of wood being expertly joined to the other. Every twenty years the buildings are razed—the most recent time was in 1993—and newly erected in precisely the same style. This is the Japanese answer to the urge for immortality.

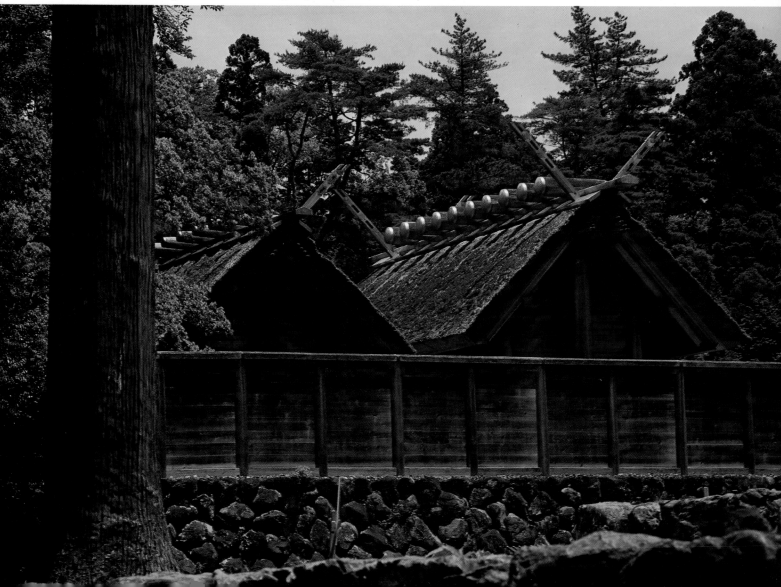

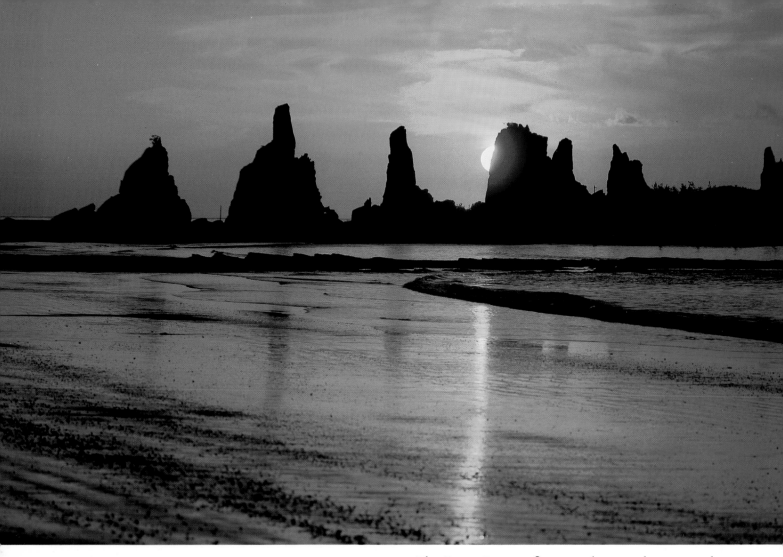

The Japan Current flows northeastward at more than ten knots, brushing the southern tip of Honshu. One of the most famous natural sights in the Kii Peninsula is the Hashikui-Iwa—so called because they are supposedly what remain of the pilings of a legendary bridge, a row of thirty weather-beaten rocks, large and not so large, extending from the coast near Kushimoto toward the small neighboring island of Oshima.

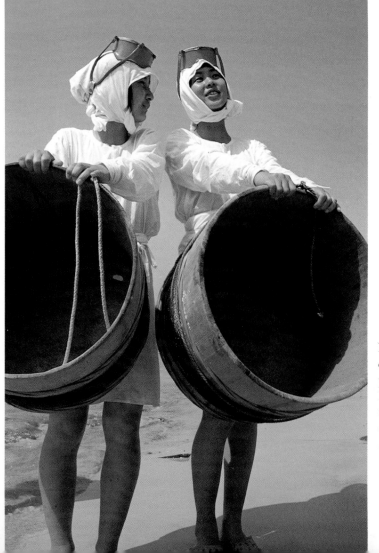

Pearls are one of the major exports of the region. The pearl center is Ago Bay, where cultured pearls are grown and natural pearls are occasionally discovered. This is where the famous Kokichi Mikimoto started the mass-production pearl business in the early twentieth century. At left are the women divers called *ama* who are now something of a tourist attraction. They are famed for their underwater prowess, which includes such techniques as holding the breath, it is said, for up to five minutes.

OSAKA

Osaka is Japan's third largest city, and, next to Tokyo, its greatest commercial center. Ideally located for commerce, it was indeed created for just that purpose by the war-lord Toyotomi Hideyoshi (1536–98), who persuaded or ordered merchants from neighboring localities to move there. Hideyoshi had his reasons. He needed a commercial center quite separate from Kyoto, that city of imperial intrigue and clan infighting, and so it was he who in effect began the first big-business boom in Japan.

Old Osaka was an innovation, a whole city of merchants created during the very times when commerce was despised by the nobility and the samurai on one hand and by the peasantry on the other, being thought too far beneath one class and too far above the other. Thus it was Osaka that first made making money a respectable activity and it was here that in 1870 the first mint was established to standardize Japan's coinage.

Literature and drama recount the snubs endured by the merchants, who were long repressed by various political factions, while also celebrating their undoubted vitality as, after each rebuff, they returned to better business and more prodigal prosperity. One does not visit Osaka for culture (for this one goes to Kyoto) but for the pleasure of being with its money-mad inhabitants.

Osaka has its own dialect and a different pace from the capital, playing Chicago to Tokyo's New York, so to speak. The Japanese make even more of such differences than the Americans, and the Tokyo-centered Kanto culture is said to be much different from the Kansai culture of Osaka and Kyoto. Among the differences is the presumed delight of the Osakan in the natural appetites. A walk down tantalizing Dotombori convinces that this is perfectly true.

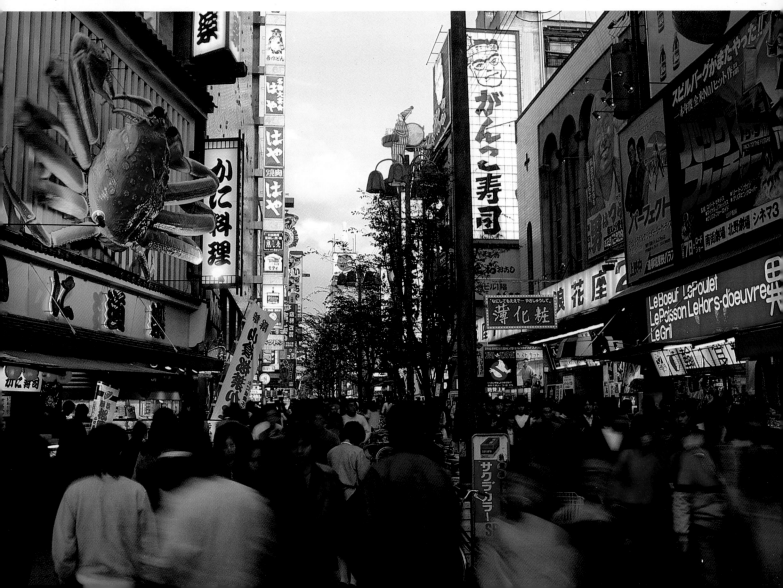

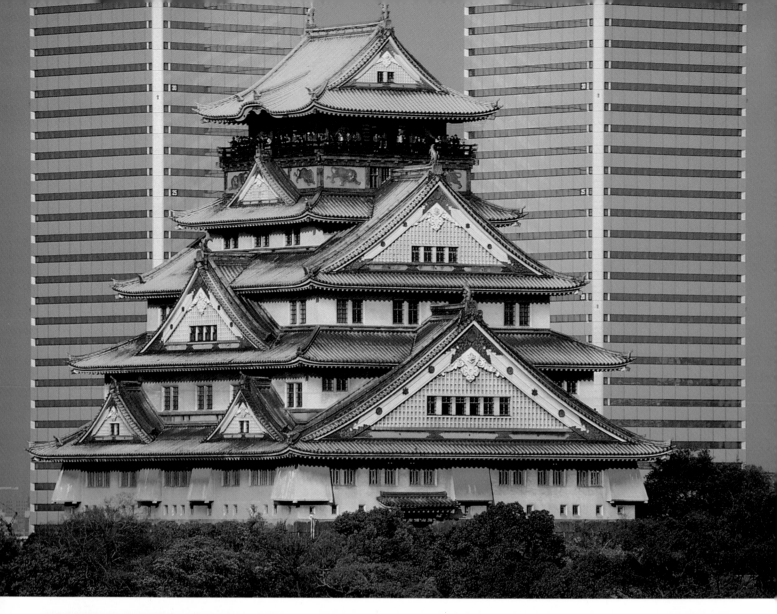

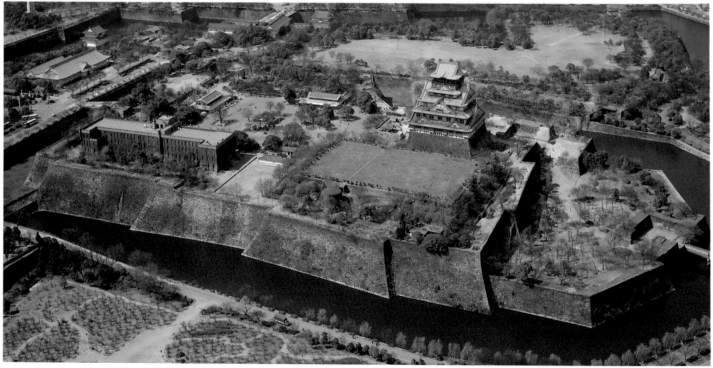

The great sight in Osaka is Osaka Castle, completed in 1586 by Toyotomi Hideyoshi. The most impressive thing about it was not its beauty nor its strength but that it was completed in just three years, a major architectural feat for the period. It was here that the Toyotomi family met its end, having been permitted to live on for fifteen years after losing control of the country to the Tokugawas in 1600. The present building, made of ferroconcrete, was completed in 1931.

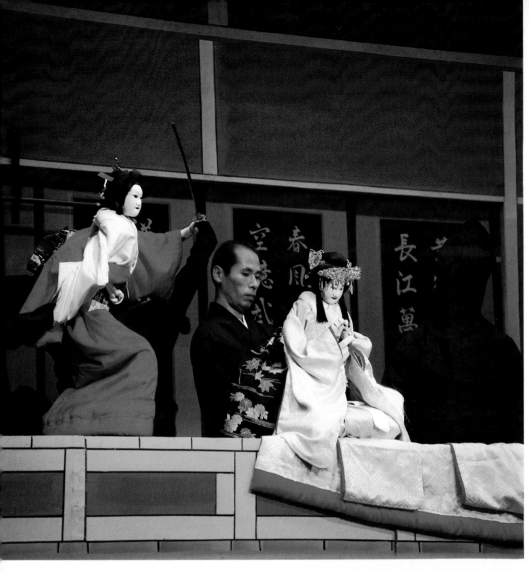

What the Kabuki was to Edo, the Bunraku puppet-drama (*left*) was to eighteenth-century Osaka. The more important puppets are manipulated by three men, the master puppeteer taking charge of the head, the body and the right hand, the others moving, respectively, the left hand and the legs or kimono skirts. Dialogue and music are provided by the chanter and the *samisen* player, who are on the dais at one side of the stage. Bunraku and Kabuki share a repertoire, many of the latter's plays having come from the puppet theater, including the most famous of all, *Chushingura*, or "The Loyal Forty-seven Rōnin."

One of the traits of the Osakan—the Tokyoite will tell you—is an excessive concern for business and for making money. Indeed, a common Osaka greeting—they will also tell you—is: "Making any money?" There are, to be sure, a large number of shrines devoted to Fudo-myo-o, a deity believed concerned with such chancy matters as business enterprises, and these shrines (such as that at Hozenjiyokocho, *right*) are very often visited.

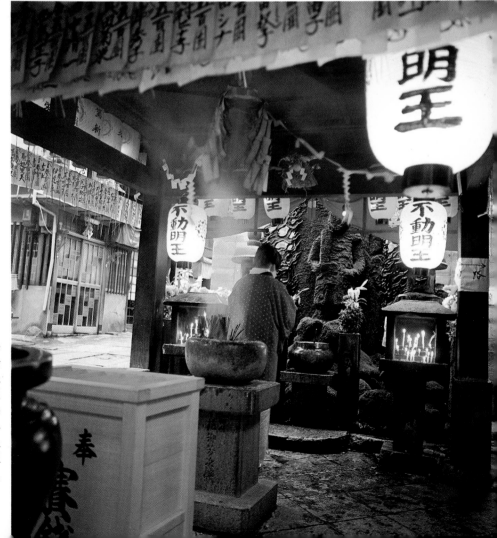

KYOTO

Kyoto, the former capital, holds firmly to its status as the home of traditional culture. Center of the nation's civilization for over ten centuries (from 794 to 1868), it is to Japan as Florence is to Italy and Granada is to Spain. Filled with temples and shrines, palaces and gardens, it presents the visitor with more of old Japan than any other place and has consequently become the major tourist center of the islands.

It is also one Japanese city in which the tourist can easily find his way. Unlike labyrinthine Tokyo, Kyoto was, from the very first, with its orderly progression of numbered streets, designed as a model city. Specifically, it was patterned after the capital of T'ang-dynasty China and originally had the very Chinese-sounding name of Heian-Kyo, or Capital of Peace. It had, and still has, nine wide streets running east to west, beginning with Ichijo (First Street) and ending with Kujo (Ninth Street) in the south, all intersected by a number of broad avenues, some of which preserve their ancient names. Though Kyoto has now spread out to the surrounding mountains, this basic grid remains, bringing to mind the plan of Manhattan, a place it in no other way resembles.

Despite centuries of war, fire, earthquake and typhoon, the original plan has been maintained, making it the most conveniently explored of all Japanese cities. Part of the reason for this continuation, Tokyo people say, is the almost notoriously conservative nature of the city's inhabitants. The Kyoto person, we are told, is innately snobbish and reactionary to an extreme. Be this as it may, and despite the impingement of the modern on the center of the city, it does seem true that the inhabitants are mindful of the traditional and have done much to keep intact, through various means, whatever remains unsubmerged by the rising tide of modernization.

An idea of what old Kyoto during its prime must have looked like is offered by the Heian Shrine (*below*). Though a late (1895) reconstruction, the buildings are a replica, on a reduced scale, of the first Imperial Palace erected in 794. Built to commemorate the 1100th anniversary of the foundation of the city, it is dedicated to the Emperors Kammu and Komei. With its magnificent gardens it gives the tourist at least some idea of what life was like more than a thousand years ago.

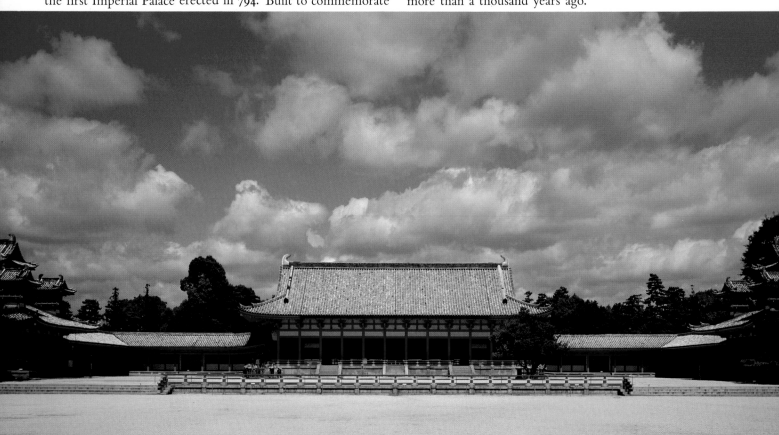

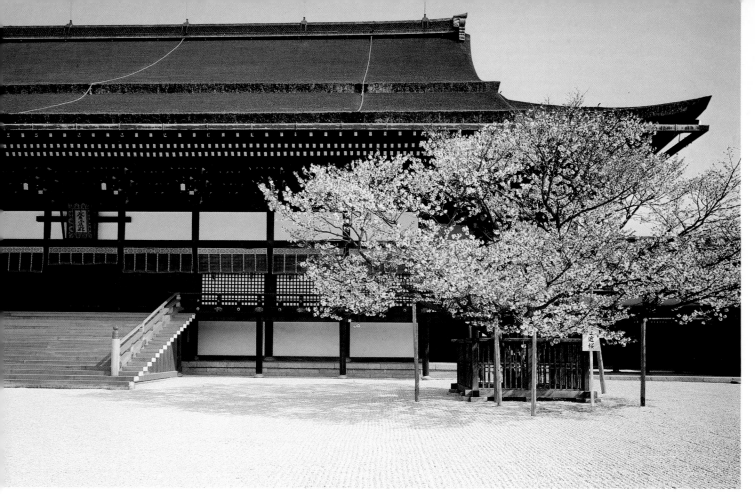

Imperial Kyoto is seen in the Gosho, the residence of the emperors from Kammu, who originally had it built in 794, through Komei, the last one to spend his life there (1867). Several times destroyed by wars and fires, it has always been rebuilt in its original style. The present buildings date from 1855. A complex of residences, assembly halls and gardens, it includes the Shishiden, the Hall of Ceremonies (*above*), and the famous Sakon no Sakura, a blossoming cherry often mentioned in the old records.

The Kinkakuji, or Golden Pavilion, was originally designed as a court villa at the end of the fourteenth century. It was there that Ashikaga Yoshimitsu, the art-loving shogun, retired and, according to tradition, used this pavilion for meditation. What was believed to have been the original structure stood until 1950, when it was destroyed by an arsonist. This exact reconstruction (*right*) was erected five years later. With its combination of gold foil and the most simple-seeming of natural surroundings, it suggests a retreat from most of the cares of the world, accompanied by all of its comforts.

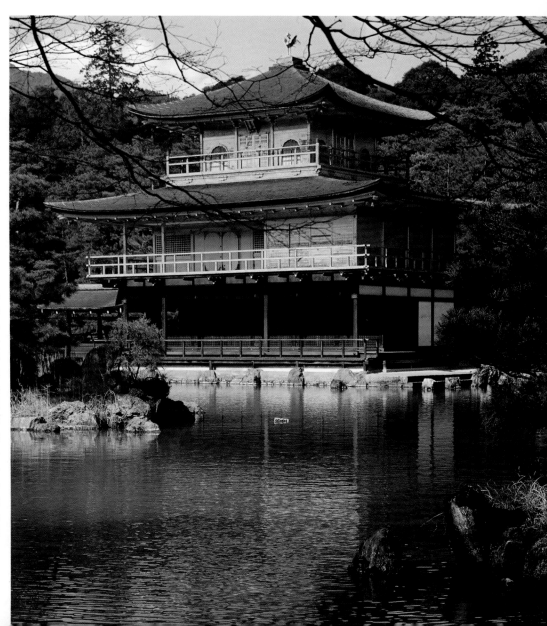

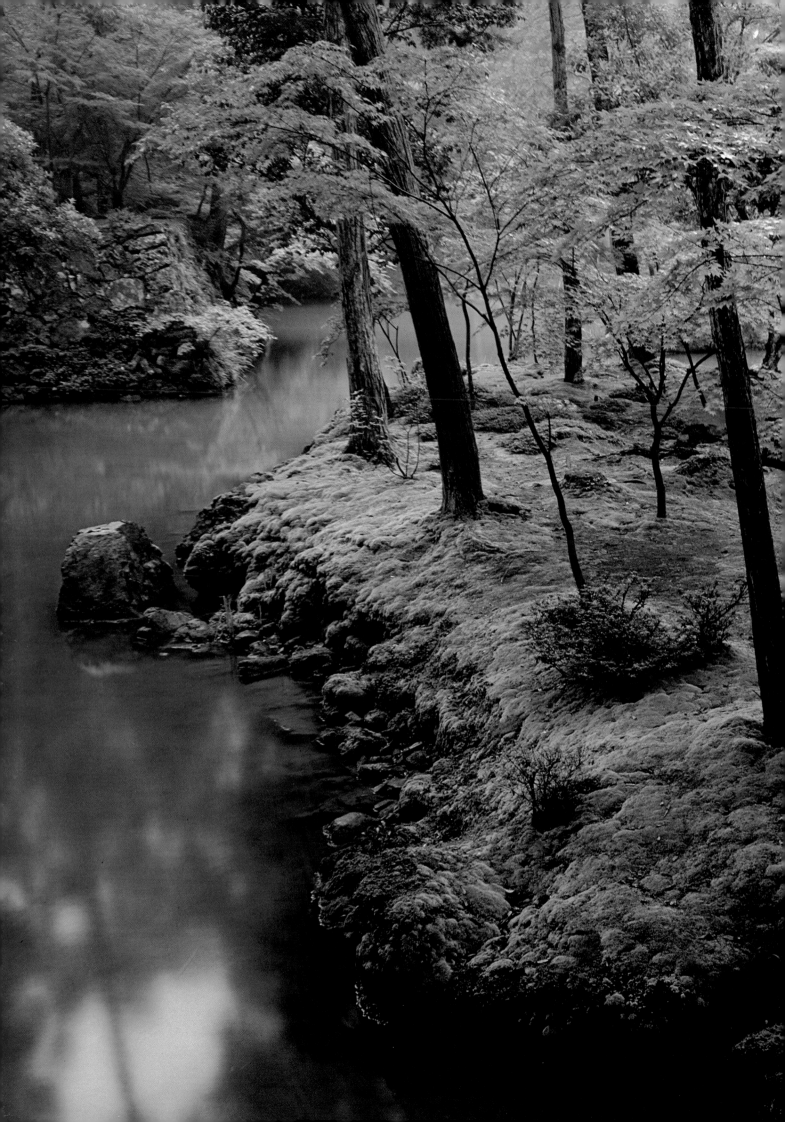

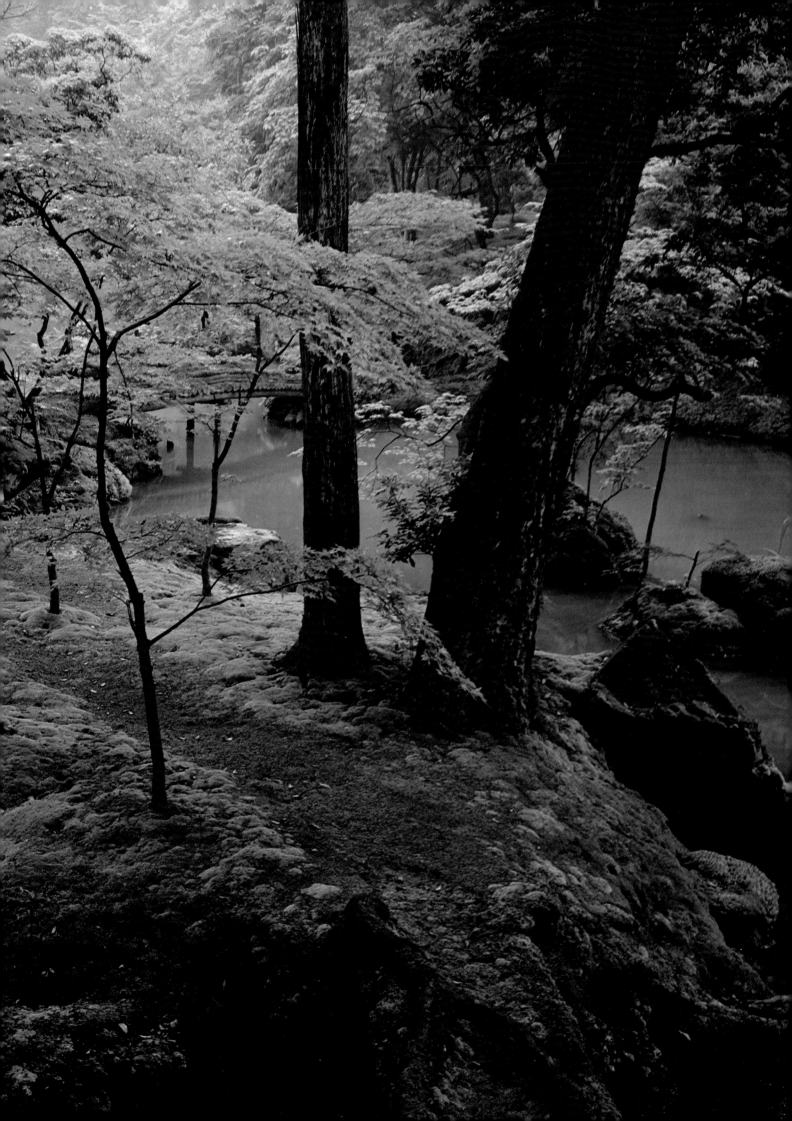

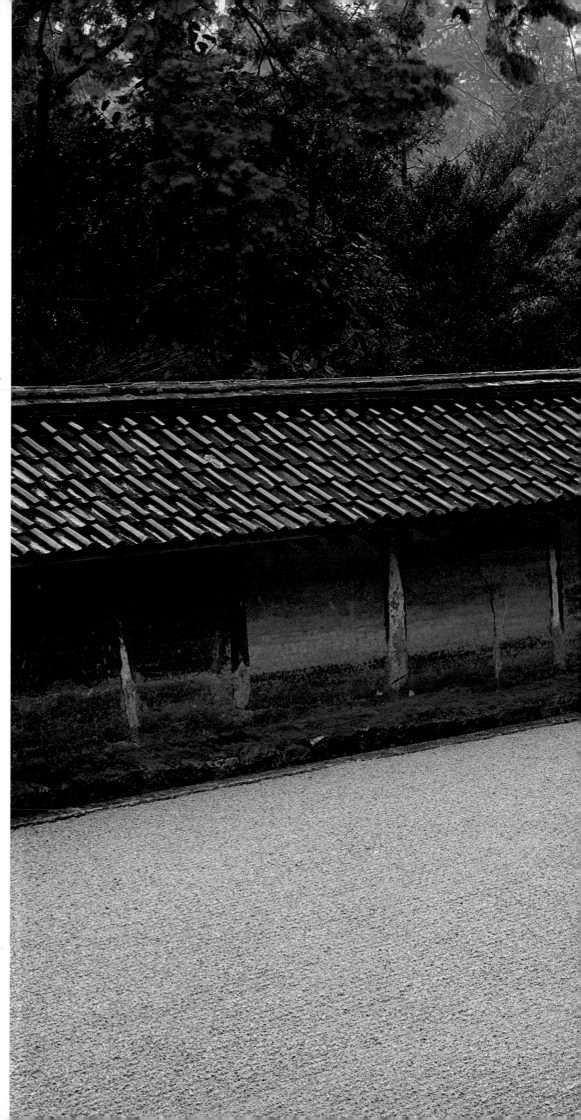

Saihoji takes its popular name of Kokedera, or Moss Temple, from its extraordinary garden (*previous page*), in which grow nearly forty varieties of moss. Though the temple itself was founded in the eighth century, the garden was laid out in the fourteenth century and remains a beautiful example of the purposely rustic, the artfully natural. The garden was actually designed most rigorously, but the effect is that of nature heightened, civilized so that it may comment upon its own beauty—a quality of many Japanese gardens, here raised to an aesthetic level where the hand of man is everywhere evident and nowhere apparent.

The Ryoanji complex (a Zen temple, as is Saihoji) is best known for its stone garden. Usually attributed to Soami, one of Japan's most highly regarded aesthetic arbiters, it is thought to have been made around 1500. Devoid of everything but sand and stones, fifteen in number, it has over the centuries been presumed to mean a number of things—islands in the sea, mountain peaks above clouds, a mandala of the great temples of Zen itself. Built as an area of contemplation, it may be all of these things or none of them.

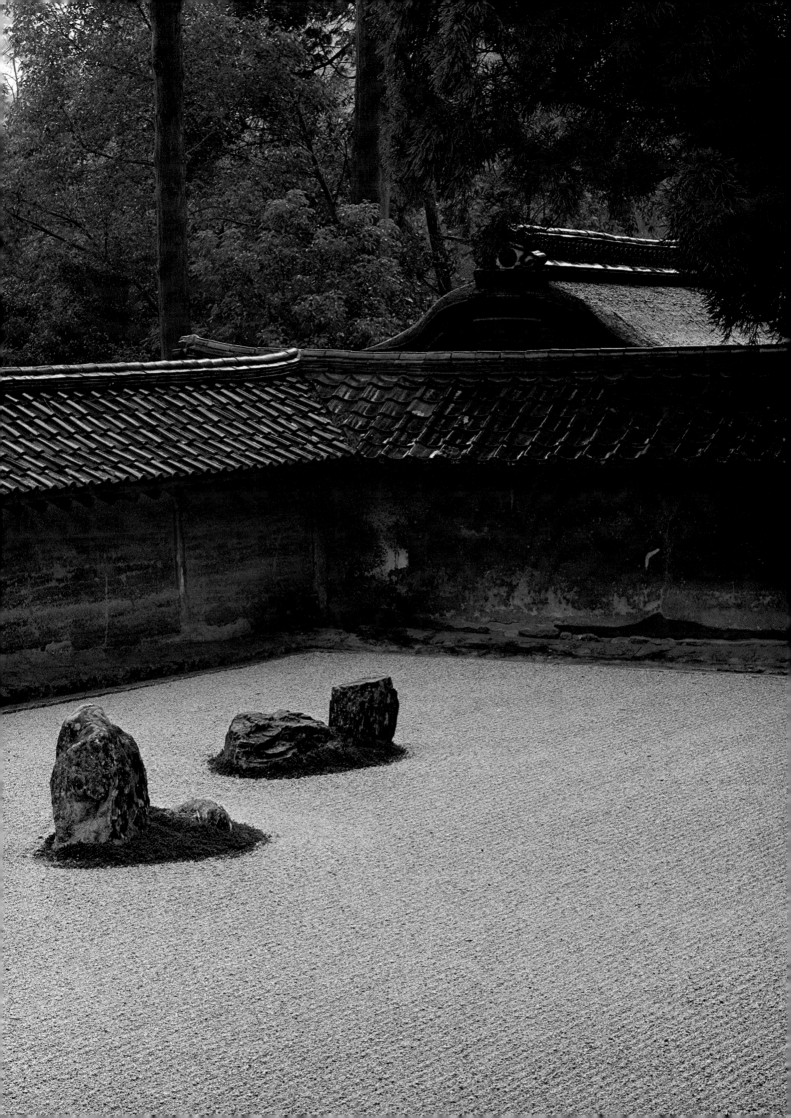

The Shugakuin Rikyu, an imperial villa encompassing seventy acres, is a series of dwellings in the most elaborate of gardens. Founded by the Emperor Go-Mizu-no-o as a place of retirement in the middle of the seventeenth century, it was restored by the Emperor Meiji at the end of the nineteenth. At left is the Kaedebashi, or Maple Bridge, set in one of the many gardens contained within this beautiful estate.

Daitokuji is one of the chief temple complexes in the old capital and one of the classic examples of a Zen monastery, its buildings and gardens having been constructed according to twelfth-century ideas of style and design. The Kohoan has seven tea-ceremony rooms, including this one (*below*), in which the garden is partially hidden by the lattice, a very Zen-like idea.

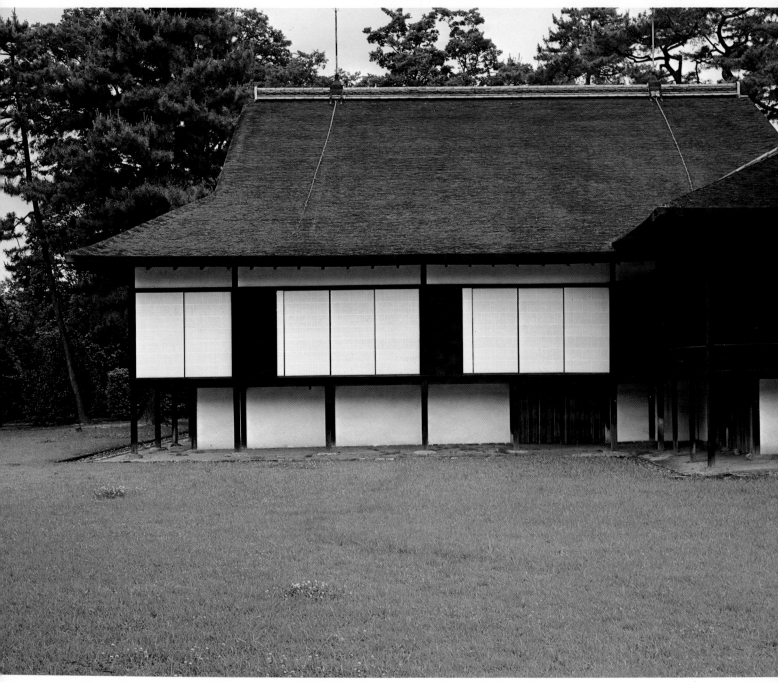

The Katsura Rikyu (Katsura Imperial Villa) is one of Kyoto's most distinctive combinations of buildings and natural surroundings, a blending of man-made structures and gardens long admired for its perfect aesthetic balance. If in the Shugakuin it is nature itself which most impresses, in the Katsura it is the craft through which nature can be redefined and still appear natural. Completed early in the seventeenth century, the villa remains the prime example of the most refined architecture of the period, set in one of its most intricately designed gardens.

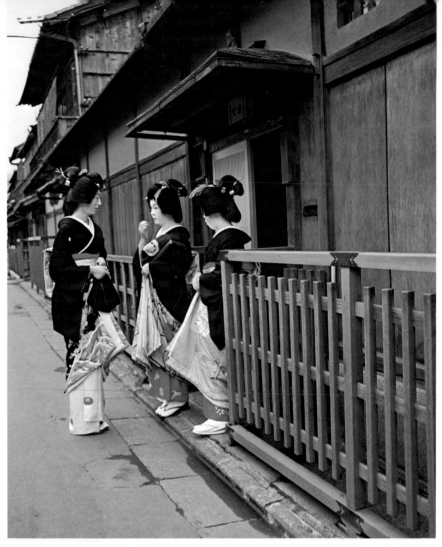

In downtown modern Kyoto, near the shops and department stores, stands the old Gion quarter, the early entertainment area of the city and still the home of the geisha. At left (in front of typical Kyoto houses and near the old Gion Bridge), these traditional entertainers are seen on their way to this party or that, a slightly self-conscious but nonetheless gracious scene from the old days, the way it once was.

For those who cannot afford private entertainment by the geisha, there is the Miyako Odori. This is a program of songs and dances performed by the entertainers of the district, both the full-fledged geisha and their younger apprentices, the *maiko*. Sponsored by the city and the geisha guild, it is, to be sure, somewhat commercialized (being a geisha is a commercial as well as an artistic enterprise), but even here much of the old traditional way lives on.

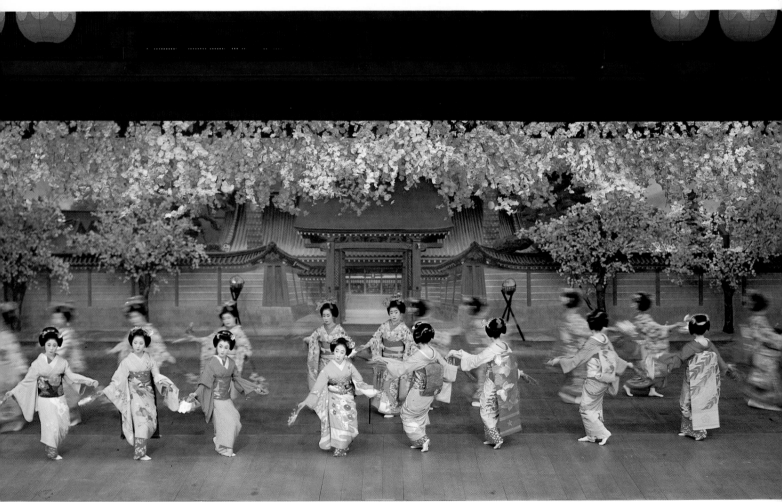

NARA

Nara is often called the cradle of Japanese civilization, the city having been the first capital of any permanence. Thus the Nara basin and the surrounding hills are replete with sites of early historical and religious importance. South of the city is the Asuka district, where numerous early emperors resided, and east and south of Nara is the ancient land of Yamato, presumably where the first clans from the southwest came to settle and where the first evidence of the very early civilizations has been unearthed. Even today this place name holds near-mystical associations for the Japanese, as in the much-praised *Yamatodamashii*, which may be translated as the "true Japanese spirit."

The city of Nara itself, built around a large and beautiful park, contains some of the finest of early Japanese structures, and in the countryside are the temple complexes of Horyuji, Toshodaiji and Yakushiji, all of which preserve much from this early period of Japanese history. There are many people who eventually prefer Nara to Kyoto. Not only is there less modernization in this much smaller city, but also the superb architecture is more of a piece and the naturalness of the milieu sets it off to better effect. Here, built against its mountain, is the beautiful Nigatsudo with its magnificent view, here is the marvelous Horyuji, and here too is the Shosoin repository, where the art treasures and artifacts of twelve hundred years ago are carefully preserved.

For less than a century (710 to 784), Nara was Japan's first official seat of government. While its abandonment perhaps reflects the custom of changing the capital upon the accession of a new ruler, antagonism between aristocrats and political-minded priests was also a factor. One of the consequences of this establishment and removal is that Nara continues to display, perhaps even better than the built-over Kyoto, early Japanese civilization as it was. One example is the view of the pagodas of Yakushiji (*below*).

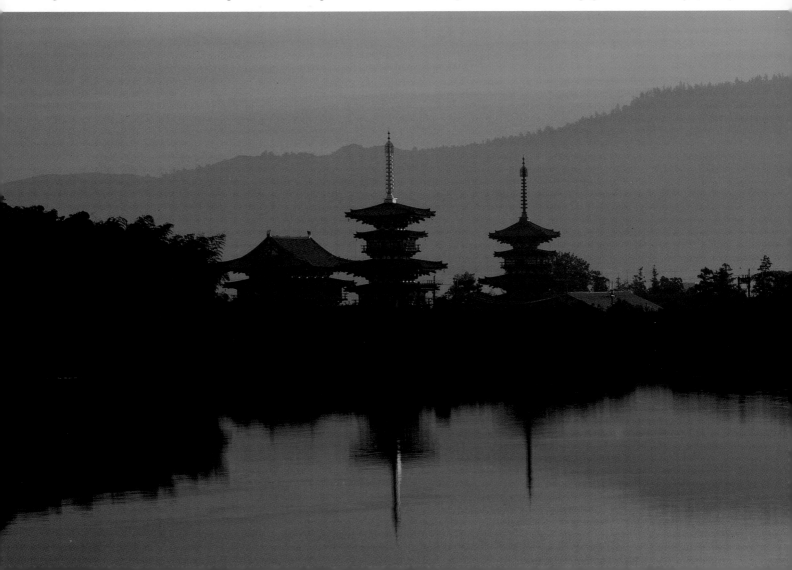

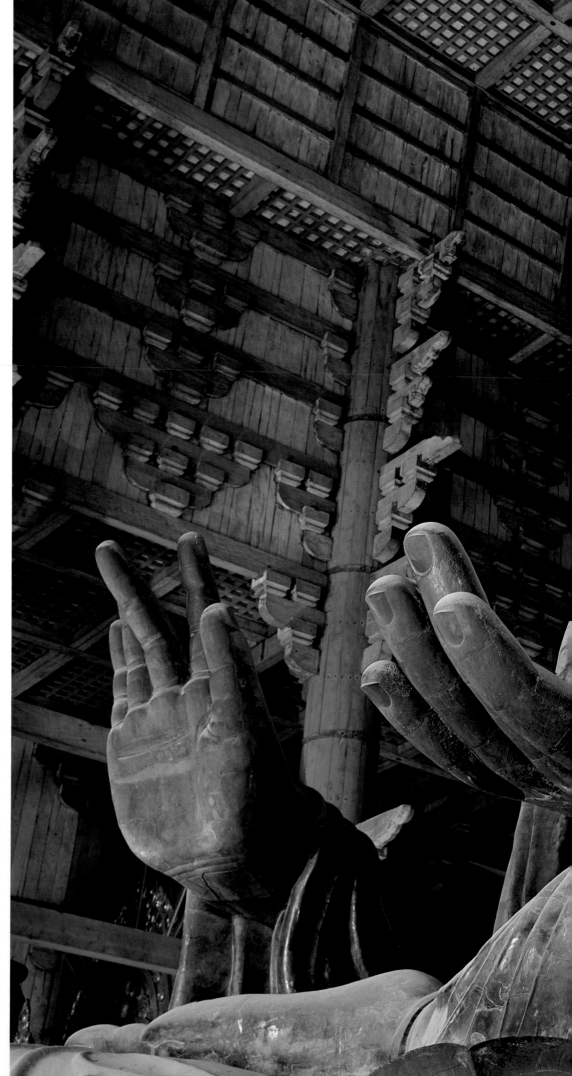

Inside the Daibutsuden, the Hall of the Great Buddha, is the massive forty-eight-foot-high bronze statue of the Buddha. Designed by a Korean artist from the Paikche Kingdom, it was successfully completed in 749 and remains a triumph of early casting techniques. The Buddha sits cross-legged and his fingers form mudra, those gestures that in Buddhism serve as sermons. The right hand shows *semuiin*, which grants absence of fear; the left shows *yogan'in*, the mudra of giving. Time itself, however, has touched the statue; both hands are replacements and the head was restored in 1692.

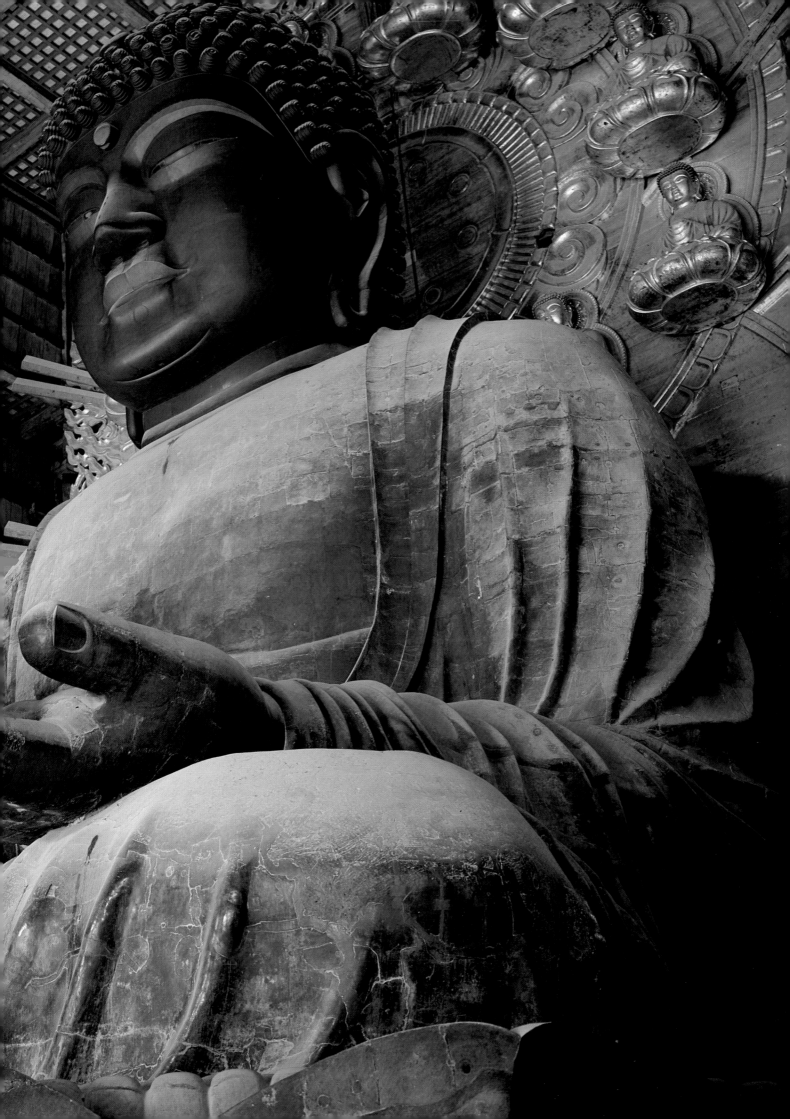

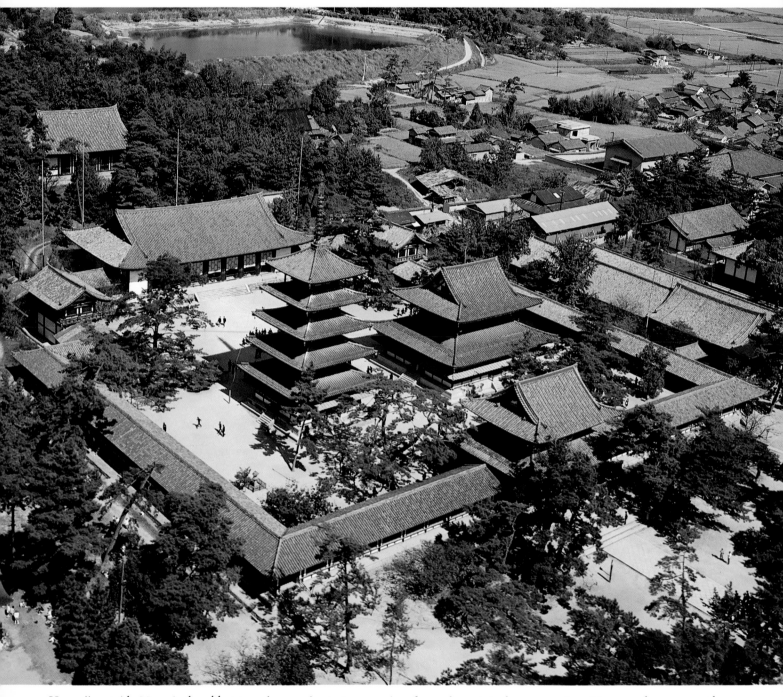

Horyuji, outside Nara, is the oldest temple complex in Japan and contains the oldest wooden structures in the world. Founded in 607, it remains today much as it was. The Kondo (to the right of the pagoda, *above*) is the original seventh-century building, while the pagoda itself, though it dates from 990, makes use of wood from the original construction. Here, perhaps more than anywhere else in Japan, one finds the abiding spirit of the country's long history, and in its grounds one discovers not only the living past but also some of Japan's greatest art treasures.

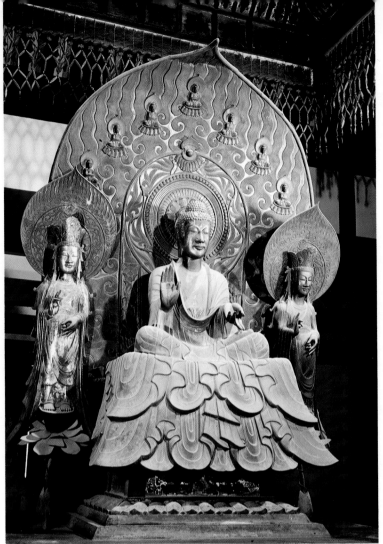

Inside the Kondo, or Main Hall, are several priceless Buddhist images. The most famous is the bronze Shakya Trinity, which was cast in 623. In the center is the Buddha, seated in the position indicative of his incarnation as Shakyamuni. He is flanked by two attendants who have become bodhisattvas, Yakuo and Yakujo. This trinity is marked both by the forceful naiveté and the unselfconscious splendor that so typify the early art and sculpture of the Asuka period. Its very human dignity, speaking across the centuries, has assured its position as a masterpiece of the first rank.

Beyond the Kondo stands the Daihozoden, or Great Treasure Hall, actually two buildings, built in 1941 and designed to house many of the treasures of Horyuji. Among these is the famous seven-foot wooden statue of the Kudara Kannon, a National Treasure and one of the acknowledged masterpieces of Buddhist sculpture. Although the Chinese influence on Japan has been widely recognized, that of Korea, equally strong, is less well known. In this Kannon, however, and in other sculpture made during the Asuka period before Chinese styles began to predominate, this influence is palpable.

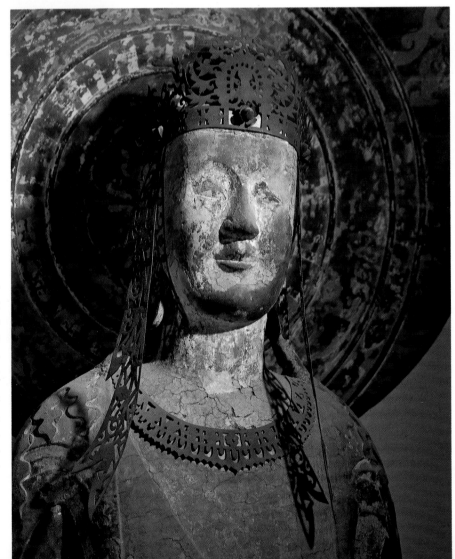

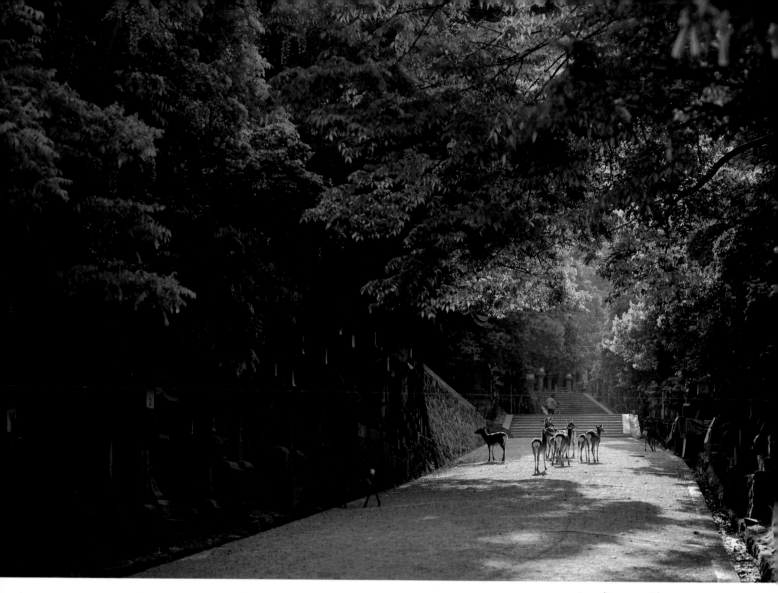

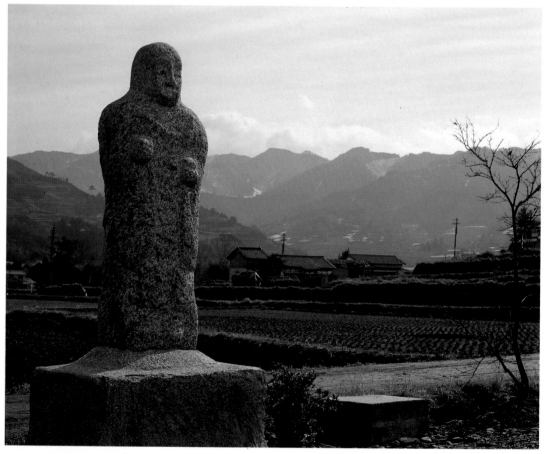

Standing amid an extensive wooded park, the remains of ancient Nara preserve a measure of the tranquillity of earlier times. Tame deer still wander through its groves, freely entering the confines of the Kasuga Taisha shrine (*above*), founded in 768.

The countryside around Nara, though now much built up, also brings to mind an earlier Japan. As elsewhere, new and old coexist, but here this close relationship seems graceful, even natural. At left is an old wayside statue, a Jizo, a minor but much-beloved deity believed to be the patron of travelers and of children (not to mention the wicked).

KOBE

To an island nation with a large population and few natural resources, trade is a matter of survival. The two busiest ports, Yokohama and Kobe, were opened to the world after the Meiji Restoration (1868), and both soon developed international settlements. Even today a part of Kobe's charm (and Yokohama's as well) are the remains of these early Western enclaves, still speaking of when the century was new.

Kobe, once the most picturesque of ports, has now become a typically Japanese harbor with ships of every nation crowding its docks, serving the great international trading nation that Japan has now become.

THE INLAND SEA

Stretching two hundred and fifty miles along the southern coast of Honshu, from Kobe to Hiroshima and beyond, is the Inland Sea. Bounded on the south and west by the large islands of Shikoku and Kyushu, it is actually a series of shallow seas and bays joined by narrow channels. In olden days, it was of much greater economic importance than it is now. Many settled along its shores, major ports grew up, and the Inland Sea became the country's first sea-trade route.

From here, too, ships could sail through the deep Kammon Strait into the Japan Sea, and by way of the Naruto Strait, with its famous whirlpool, or the Bungo Channel directly into the Pacific. Island towns sprang up at the various points where the sailing ships would wait for the tides, and some of them (Mitarai on Osakishimojima, for example) became important and had many civilized amenities, including a busy licensed quarter. Now, however, the ships steam past, the islands are no longer economically important, and the area has become pleasantly backward. Pirates, once the bane of government and mercantile shipping, have long since disappeared, and the original industries—salt kilns, stone quarries—are of only local importance, with the happy consequence that the area is still beautiful and the way of living is still leisurely.

The Inland Sea's proper name is Seto Naikai. Holding at least a thousand islands, it may have been the route by which the early Japanese migrated from Kyushu to the Kinki district. In Hiroshima Bay lies Miyajima. Here the great *torii* of the Itsukushima Shrine, standing in the tidal waters, has long been one of Japan's three classical "most beautiful sights," the other two being Amanohashidate, northwest of Kyoto, and Matsushima, at Sendai in the Tohoku District.

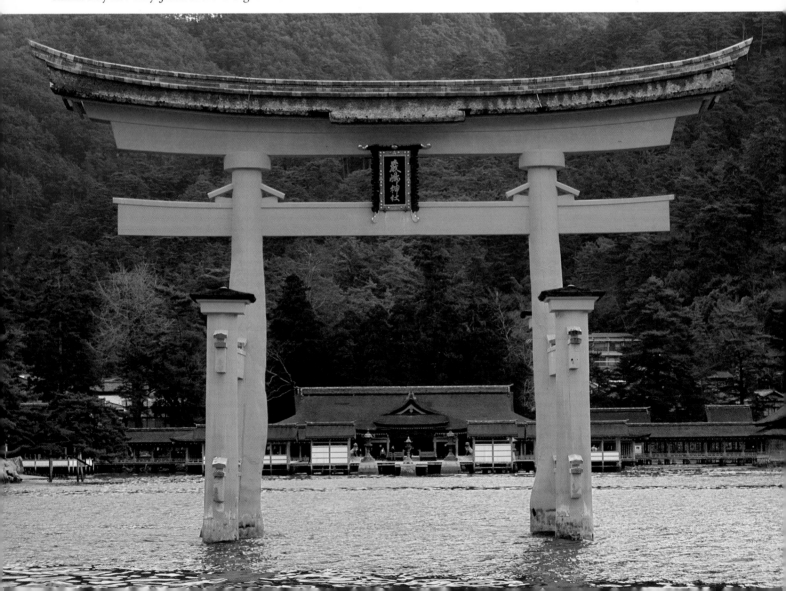

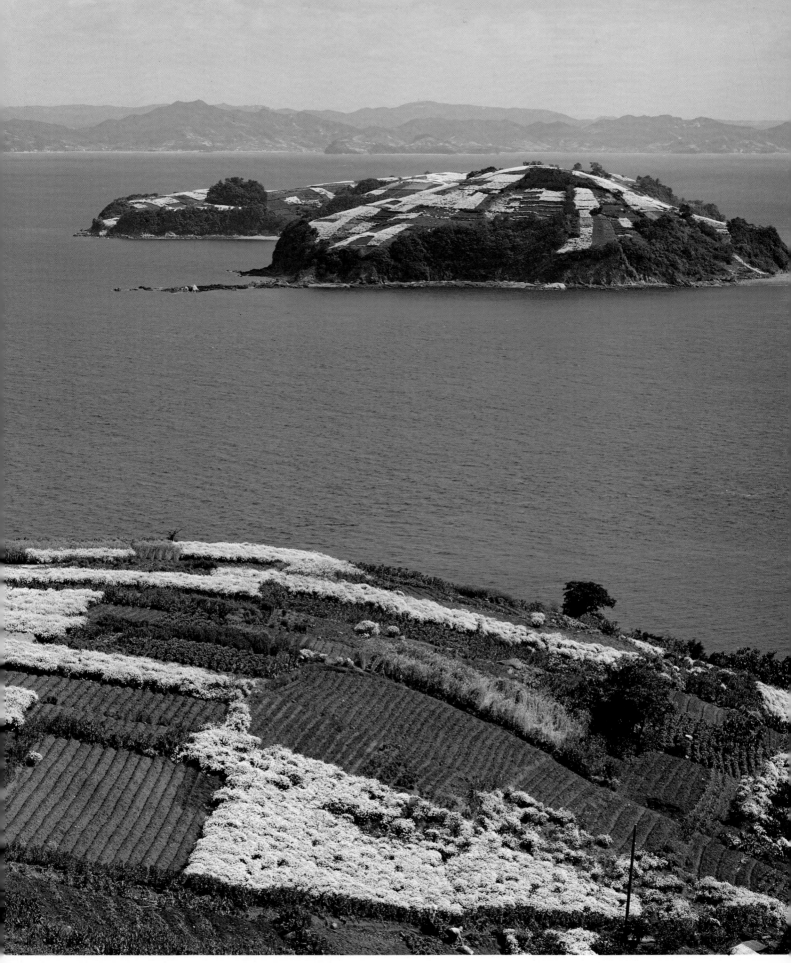

From the heights of Washuzan, near Okayama and the museum city of Kurashiki, is one of the traditionally appropriate places from which to view the islanded expanse of the Inland Sea. With the mountains of Shikoku in the distance, one island after another stretches to the horizon. Water is often scarce on these otherwise idyllic islands, but traditional methods of terracing and channeling, and much hard work, can make even land like this productive.

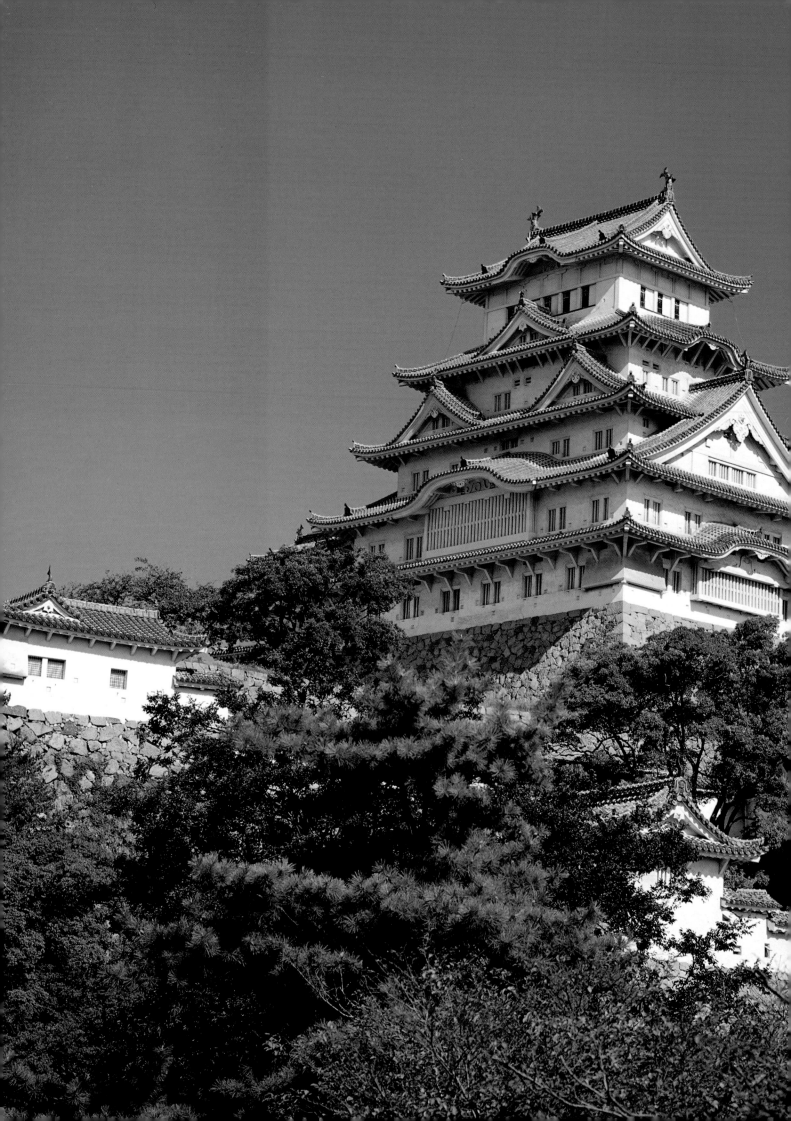

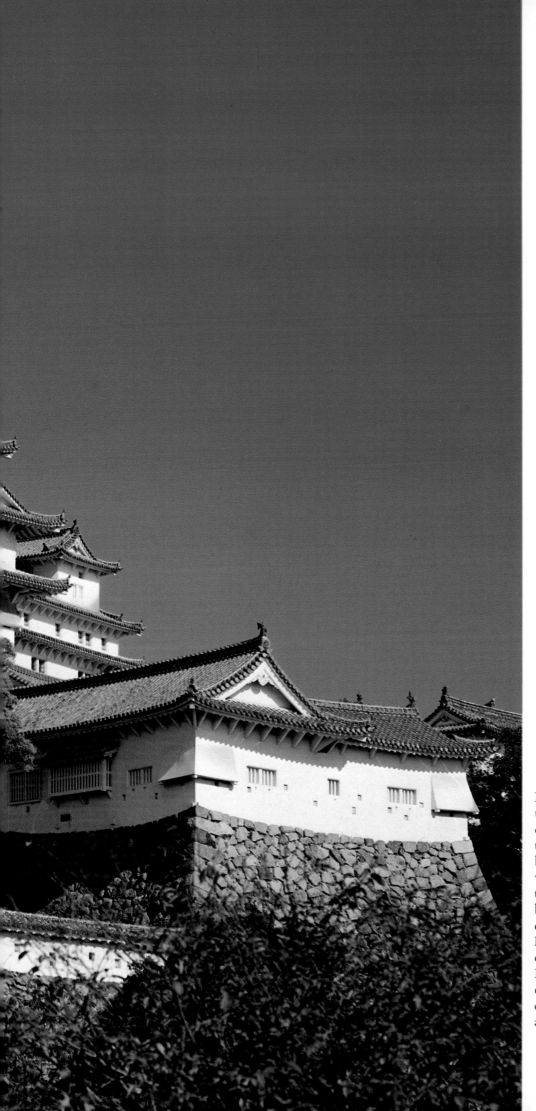

Between Kobe and Okayama is the town of Himeji, where stands one of the country's most perfect fortified castles, the Shirasagijo, or Egret Castle, so called because of a poetic likeness between the whiteness of the structure and that of the water birds which live on the plains below. Completed in the seventeenth century, it was later much enlarged. Never completely destroyed, it was occupied by various daimyo until 1868. Between 1956 and 1964, the castle was entirely renovated, and today it stands as one of the finest examples of early castle architecture in Japan.

51

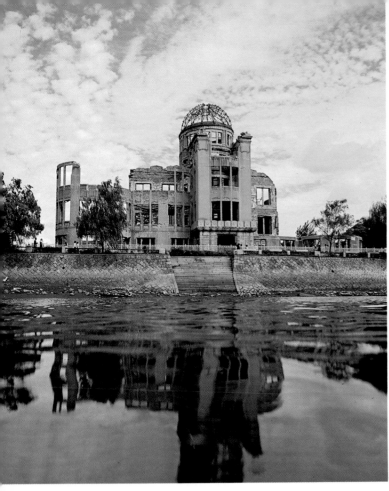

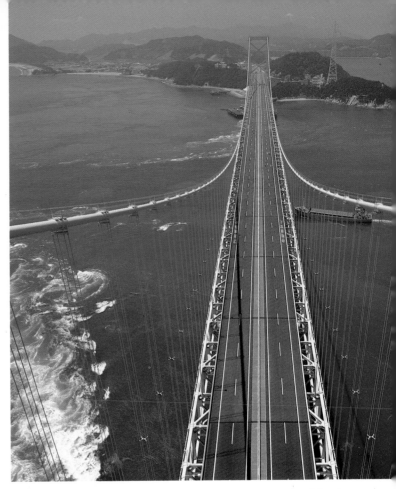

A major port and commercial capital on the Inland Sea is the city of Hiroshima. An industrial center during World War II, it was obliterated in 1945 when the Americans exploded the first atom bomb over it. The second bomb three days later destroyed Nagasaki in Kyushu. Though Hiroshima is again a busy city, a single remnant, the shell of the Industrial Exhibition Hall, stands as both a memorial and a reminder.

Reaching over the Inland Sea are a recent series of bridges, known collectively as the Seto Ohashi. The first to be completed was the Onaruto Bridge (*above*), which spans the straits between Awaji Island and Shikoku. Now the great whirlpool of Naruto, long a terror of navigators, roars impotently at the motorists overhead. Shikoku is now open to all of the pleasures and sorrows of modern Japan.

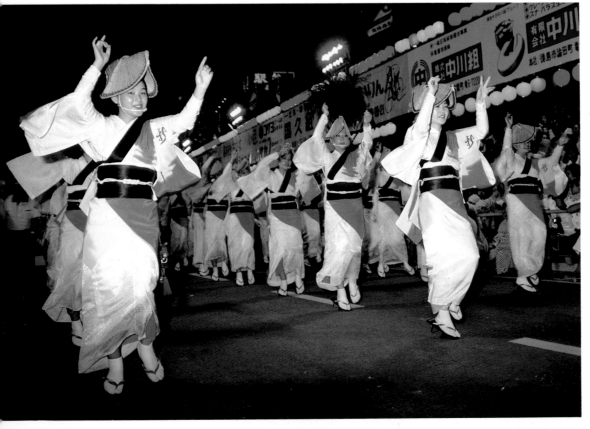

Japan, however, never entirely dispenses with the past; something always remains. One example would undoubtedly be the very popular Awa Odori, an August dancing festival in Tokushima Prefecture, compared by the local inhabitants to the famous carnival of Rio de Janeiro. The entire city, its population swollen by hundreds of tourists, takes to the streets for an orderly orgy of music and dancing. Like most city festivals, it has, over the years, become commercialized, but even now one can detect hints of the seriousness and innocence of bygone days.

KYUSHU

Kyushu, the large southern island, is the part of the country having the longest cultural ties to mainland Asia. Here were the ports to which came ships from China and Korea. Here, too, at modern Hakata, is where the Mongols attempted two unsuccessful thirteenth-century invasions. And here also, at Nagasaki, was the single port through which foreign goods and culture trickled into the country while it was closed during the long period of seclusion (1630s to 1859) imposed by the Tokugawa government.

From the foreigner's point of view, Japan fell asleep in the age of Elizabeth and awoke during the reign of Victoria. From the Japanese point of view, however, this was a rich period of peace and consolidation—as well as repression and dictatorship under the firm tutelage of the military rulers—and of development of popular forms in art, literature and drama, all undisturbed by the events taking place in the rest of the world.

Even now Nagasaki is considered attractively foreign by the Japanese. Certainly this island, almost tropical at Kagoshima on the southern tip, is thought of as being distinctly different from the others, and Japanese tourists flock to stare at Aso (the world's largest active volcano), to pick bananas in Satsuma, and to enjoy the waters of the one-hundred-fifty-odd hot-spring spas.

Japanese civilization began in Kyushu, tradition maintaining that it was from here that the first emperor, Jimmu, began his long eastward expedition. Among its cities the most famous is Nagasaki. Fearing political designs, both Hideyoshi and the Tokugawas banned foreign religions, but the Japanese Christians made up for their lack of numbers by their steadfast devotion. Below is a plaque to twenty-six native and foreign believers who were executed here in 1597.

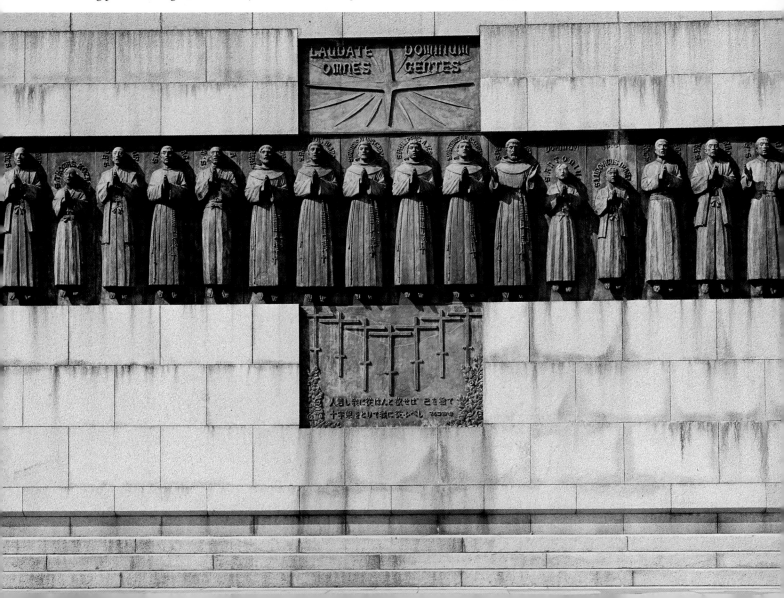

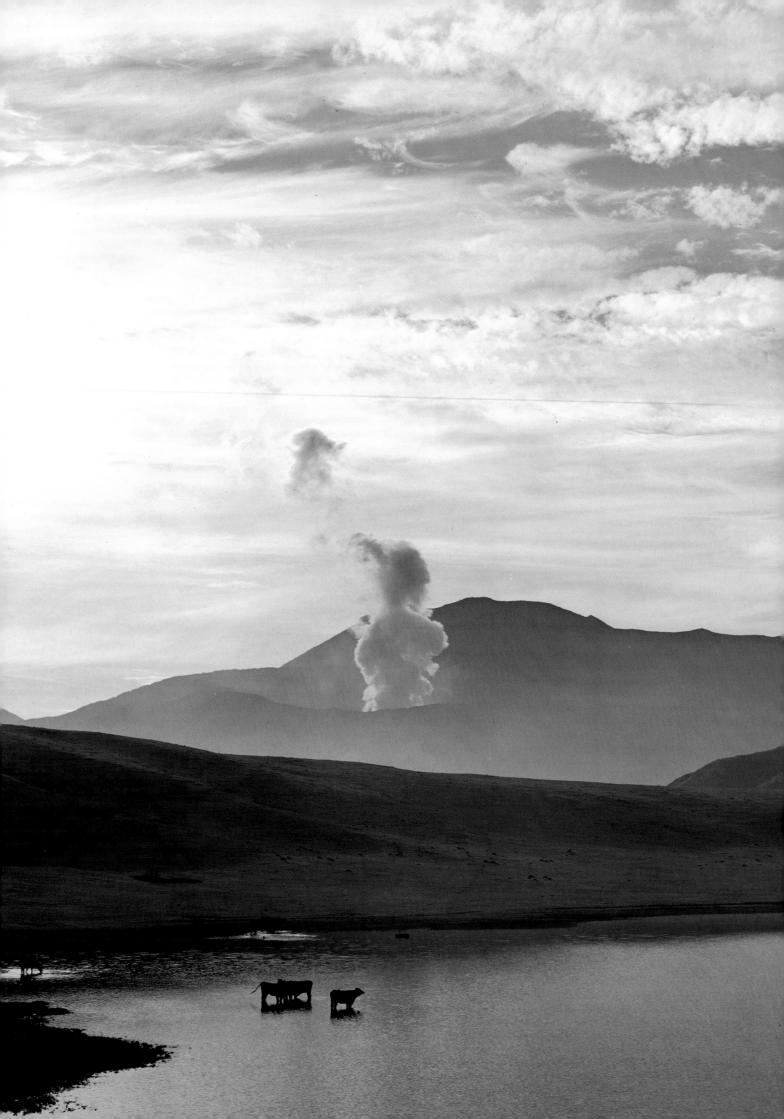

Southwest of Kyushu is a chain of subtropical islands ending in the Ryukyu archipelago, where the traditional culture, since the fourteenth century much influenced by China and Southeast Asia, is so different from the mainland that most visiting Japanese feel they are in a foreign country. Modern civilization is just now menacing the smaller islands with their clear blue waters and great marine riches.

The capital of Okinawa Prefecture is Naha, totally destroyed during World War II, though now largely rebuilt. These islands, of which Okinawa is the largest, have had a long and troubled economic history but have also managed to create their own unique culture and distinctive arts and crafts. An example of traditional architecture is the Shurei Gate, which belonged to a vanished castle. A casualty of the Battle of Okinawa, it was reconstructed in 1958.

Though not the highest mountain in mountainous Kyushu, Aso is the most spectacular, since it is not only actively volcanic but very large. Comprising five peaks, it contains four extinct craters and Naka-dake (*left*), which is continually smoking. During its eruptions (the last in 1979), it showers ash and pumice as far away as Kumamoto. Spread out in front of it is Kusasenrigahama, a vast grassland located on the floor of an even larger ancient crater.

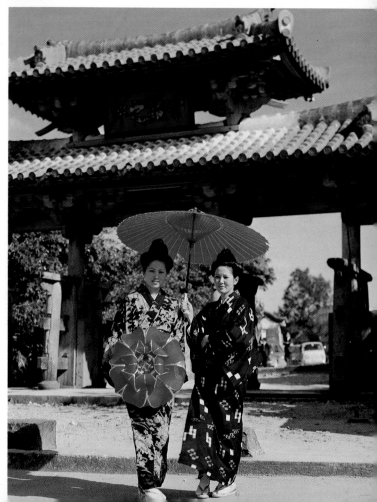

THE TOHOKU DISTRICT

The most northern district of Honshu, Tohoku, consists of six prefectures and some of Japan's densest mountains. Freezing wintry winds from Siberia make the western side of the district part of the famed "snow country."

It was in this region that the poet Basho (1644–94) traveled and wrote his *Narrow Road to the Deep North*, and it is here that tradition most tenaciously clings. Life has never been easy in Tohoku, and the area is often considered backward by the more progressively minded. If this is so, it is perhaps not surprising that the finest folk festivals, the best rural architecture, some of the country's most delicious cooking and many of its most typical moral virtues—practiced by a hard-working people, frugal but generous, alive to nature and dedicated to the land—are also found here.

Among the most charming of the country festivities is the Kamakura Festival in Akita Prefecture. Children build snow huts, in which they entertain and amuse themselves and each other. They take off their shoes or boots—as all Japanese should—before entering to partake of the steaming *nabemono* and the bright winter *mikan* (tangerines).

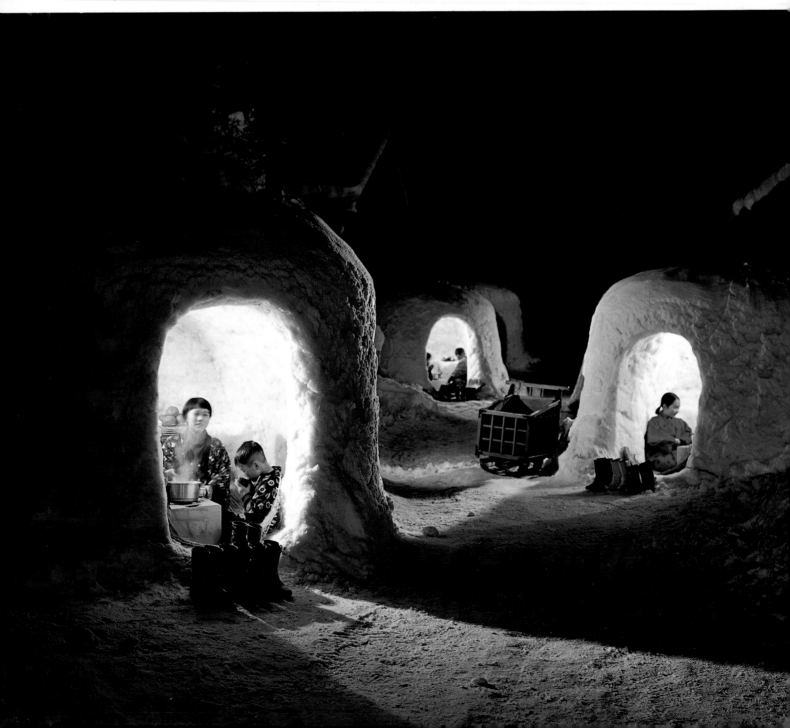

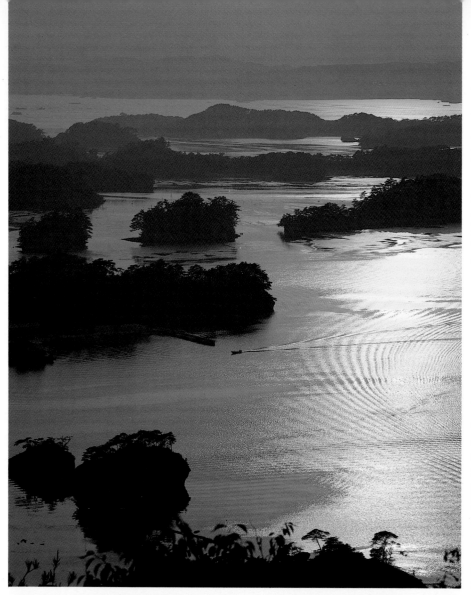

Another of Japan's "three most beautiful sights" is Matsushima, less than an hour from Sendai. Hundreds of pine-covered islands, most of them small, all of them picturesque, dot the bay and offer varied beauty to the boating viewer. Equally celebrated in all four seasons, this tranquil view has inspired many an ink painting and an uncountable number of cogent *haiku.* Early connoisseurs were agreed, however, that the very best view was in deep winter, when the pines and rocks are fantastically covered with snow.

The Nebuta Festival is one of Tohoku's oldest and most colorful yearly events. Held in August in the prefectural capital of Aomori, across the Tsugaru Strait from Hokkaido, it is said to have originated from an event that took place in the eighth century, when a local warlord misled and subjugated his enemies by simulating men and animals using *nebuta,* or effigies. The highlight of the festival is the procession of enormous floats, lit from inside and representing all manner of fabulous warriors, birds and beasts.

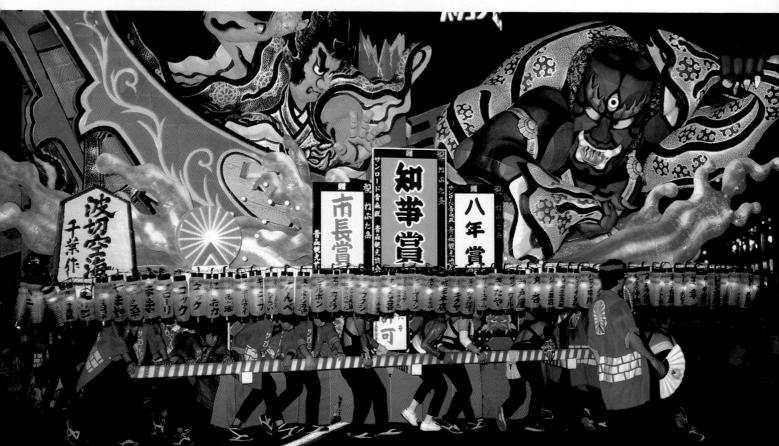

HOKKAIDO

North of Honshu, the island of Hokkaido, second largest in size, contains only slightly over five million people, not even half of Tokyo's population. As this would indicate, Hokkaido is the most sparsely settled and the least industrially developed section of the country. The few remaining Ainu, Japan's aboriginal race, live here now, having been pushed northward over the centuries by the people from Yamato whom we now call the Japanese.

Here too is an endowment of vast tracts of wilderness, the Hokkaido salmon and the last of the Hokkaido bear. Forests cover over 70 percent of the land, and the fine fishing grounds account for over 20 percent of the country's total off-shore catch. Hokkaido is consequently Japan's last frontier, and something of the American attitude toward its Old West is seen in the way the Japanese feel about their own northern island. It is a hard land of promise, where perhaps fortunes are to be made, but where at the same time Japan as it once was continues to live.

Snowy Hokkaido also has its volcanoes, active, dormant and extinct, and nearly half of the country's largest lakes. Below is Lake Penketo, a name of obvious Ainu origin, in the Akan National Park.

LAND AND CLIMATE

Japan is an arc of islands, the four large ones—Honshu, Kyushu, Shikoku and Hokkaido—and thousands of smaller ones lying between the Asian mainland and the Pacific Ocean. The archipelago stretches some eighteen hundred miles from northeast to southwest and encompasses a varied but generally temperate climate showing both maritime and continental influences.

Japan is also situated in that band of continual seismic and volcanic activity that borders the Pacific Ocean, and since the mountain-building processes of faulting and warping continue, the landforms are basically unstable. Earth tremors occur often and earthquakes are not infrequent, many of them originating offshore beneath the Pacific and even now sometimes creating new volcanic islands.

Mountains are everywhere, forming more than four-fifths of the land surface. These are of fairly recent origin, compared with the continents, and for the most part are more notable for their ruggedness than for great height. Dormant these past 270 years, Mount Fuji is one of approximately 250 volcanoes, a number of which are still active.

Excepting Okinawa, climate in all regions is of a seasonal nature. It is the combination of the action of ocean currents (the Kurile, approaching Japan from the Arctic, and the Japan Current, coming northeast from the Western Pacific), and mountains and winds that create the typical climate of Japan. The Japan Current divides into two streams when it encounters the archipelago. The main stream flows northeast along the Pacific coast and creates the temperate winter climate of Kyushu and those Honshu peninsulas—Kii, Izu, Miura and Boso—which it passes. The lesser stream flows between Kyushu and the Korean peninsula into the Japan Sea, where in winter frigid winds from the mainland pick up great quantities of moisture, making western Honshu snowbound (some areas for as long as five months). These winds, however, are blocked by the Alps and the mountains of northern Honshu, so that eastern Japan has little snowfall.

No area of the country is lacking in precipitation on an annual basis. In the summer, there being no mainland winds, western Honshu has no regular pattern of rainfall. It is now the turn of the eastern half. Air masses, particularly low-pressure troughs, moving eastward and northward in the Pacific bring the rainy season in June and July and typhoons, mostly in September and October, to Kyushu and eastern Honshu. Again the surface winds are blocked by the mountains, with the result that the other half of Honshu has no rainy season at all. Thus the Pacific coast winter is dry and relatively warm, while summer is, initially, rather wet.

Flatter areas suitable for habitation and cultivation are located for the most part along the coast. The Kanto Plain (around Tokyo) is the largest of these; other major ones are the Nobi Plain in the Chubu District, the Tsukushi Plain in Kyushu and the Ishikari and Tokachi Plains in Hokkaido. But the arable land amounts to only about 15 percent of the total land, which itself is not large, being 10 percent less than the size of California. Since the population has quadrupled since the middle of the nineteenth century (as has world population) to about 120 million, self-sufficiency in food is impossible. Importation of such necessities is the only feasible course.

On the other hand, this is a green land, well-forested because tree farming has been long practiced. And the crenellated seacoast is of extraordinary length and contains many fine natural harbors and an abundance of sea life. It is also, traditionally, a very beautiful country, one where, until now, man has lived upon the bounty of an apparently benevolent nature, which he has revered and been guided by.

HISTORY

Though Japan considers itself one of the few homogeneous countries left in the world, the origins of the Japanese were apparently varied. Paleolithic tools indicate early habitation, though the routes of migration are obscure. Two early settled cultures were the Jomon, from around 7,000 to 200 B.C., and the Yayoi, from around the third century B.C., the former named for its pottery remains. By around the fourth century A.D., migration from Kyushu to the present Nara area had created the first recorded state, the Yamato court.

This first period was marked by internecine strife and the growing influence, through diplomatic and religious missions, of China and Korea. Eventually the Fujiwara family emerged as the strongest faction, and there was a firm centralization of political power in the court and the first compilation of codes of law. During this Nara period (c. 710 to 784) were compiled the *Kojiki* (Record of Ancient Matters) and the *Nihon shoki* (Chronicles of Japan)—both valuable if sometimes unreliable sources of historical information—and the *Man'yoshu* anthology, a collection of nearly five thousand early poems.

The removal of the capital to Kyoto resulted in a consolidation of imperial power and the refinement of the earlier and somewhat austere culture into that luxurious civilization we now call the Heian period (794–1192). Here the arts flourished, and here Murasaki Shikibu wrote the world's first real novel, *The Tale of Genji*, and Sei Shonagon compiled her essay collection called the *Pillow Book*.

Late in the eleventh century, the Fujiwaras lost their hold on the important offices of imperial regent and imperial councillor, and the country was polarized around the Taira (also called Heike) family, which had imperial sanction, and the opposing clan, the Genji. The civil war that followed saw the victory of the Genji clan, the extermination of the Tairas, and a great loss of power and authority for the emperor and his court. It also inaugurated the Kamakura period (1192–1333), because the victorious Minamoto Yoritomo became, in effect, the new ruler of the country. Receiving the title of *shogun*, or generalissimo, he organized the *bakufu* (shogunate government) at the eastern port of Kamakura. The culture of this period was vigorous, manly and martial, quite unlike the luxurious and often effete culture of the Heian period. The resulting literature was restricted largely to such historical narratives as *The Tale of the Heike*, chronicling the fall of the losing side, while the arts included the making of armor, particularly swords.

As a result of continued intrigue and open war with imperial forces in Kyoto and complications caused by the unsuccessful Mongol invasions by Kublai Khan, the Kamakura faction lost power and was eventually defeated by the forces of Ashikaga Takauji and Emperor Go-Daigo, who shifted the seat of government back to Kyoto.

This defeat ushered in the Muromachi period (1336–1573), an era of great social instability which saw constant warfare among provincial military leaders. It was also during this time that much of what we now know as classical Japanese art was formed—the No drama, the tea ceremony, and *ikebana* (flower arranging).

The last decades of the sixteenth century, known as the Momoyama period (1573–1600), were marked by castle construction and the bold fine arts that appealed to the dominant military leaders of this time. It was during this period that Oda Nobunaga (1534–82) began the final unification of the country, a task continued by one of his generals, Toyotomi Hideyoshi (1536–98). In 1600 a third general, Tokugawa Ieyasu, subdued all rivals and established a new government in Edo (now Tokyo), thus begin-

ning the Edo period (1600–1868). The stratification of the social structure was firmly set: nobles at the top, then warriors, or samurai, then farmers and finally the *chonin*, or townspeople. Peace was maintained, but it was also an era marked by the closing of the country to most foreign intercourse. The new arts that developed and flourished during this time included Kabuki, Bunraku, and *ukiyo-e*.

The reasons for the demise of the Edo government are various, but among them were the economic hardship of the lower classes, government impoverishment resulting from the capitalism of the merchant class and repeated demands by foreign powers for trade and diplomatic relations. When Commodore Perry made his famous visit in 1853, the weakened government had to concede to his demands. The Edo shogunate was finally toppled in a coup d'état which restored power to the Emperor Meiji, marking the beginning of the Meiji period (1868–1912).

This restoration ushered in the modernization of Japan, and along with Western technology came Western ideas. Japan not only adopted the railroad and the telegraph but was exposed to ideas of liberty, equality and civil rights. A parliamentary system was adopted, the Meiji Constitution was completed in 1888, and in the following year, the first Diet session was convened.

As Japan became a member of what is now called the family of nations, it also encountered some of the perils of modernization, among them war. Bickering between Japan and China resulted in the Sino-Japanese War (1894–5), a conflict which Japan won. The penetration of Russian troops into Manchuria instigated the Russo-Japanese War (1904–5). Again Japan was successful.

During the short Taisho period (1912–26), Japan consolidated its economic position and strengthened its international ties. It sided with the Allied Powers in World War I, though it partook in little fighting. At the same time, the military, historically a major element in the country's administration, began to intrude into the civil government.

As the military faction gained power, Manchuria was annexed in 1932, and in 1937 the clash of interests provoked armed conflict, again with China. This time, however, both Great Britain and the United States were also provoked and retaliated with boycotts and blockades.

Japan, now fully armed, began invading neighboring lands, calling this the creation of the Great East Asian Co-Prosperity Sphere. The West recognized this as further imperialistic expansion and the result was World War II—Japan, Germany and Italy against Great Britain, France and the United States.

The Pacific War (1941–5) ended with the complete defeat of Japan and the destruction of virtually every major Japanese city. This was followed by a seven-year (1945–52) occupation of Japan by the Allied Powers, which dispossessed Japan of all territories except for the home islands. In 1952 the San Francisco Peace Treaty was signed.

Having failed in its military adventures, Japan renounced militarism, adopted a new constitution, and began a program of economic reconstruction. The most important factor in Japan's new prosperity became international trade. No longer a major military power, Japan went on to become a major economic power.

 LANGUAGE

The Japanese language has, like the majority of languages, both spoken and written forms. It also has a comparatively narrow grammatical base and an uncommonly large vocabulary. The phonetic base, too, is rather narrow, the number of vowels and consonants being roughly two-thirds those in English. All the consonants have reasonably close equivalents in English, as do the five simple vowels. *A* is pronounced like tha *a* in mama, *i* as in east, *u* as in moon, *e* as in set, *o* as in oh. The length of time a vowel is pronounced is significant. It is either very short or of double length, hence the macrons found over *a*, *o* and *u*. The *u* is sometimes elided (Asakusa—Asak'sa; *sukiyaki*—*s'kiyaki*), and there are also very occasional irregularities in consonant pronunciation. In the Tokyo dialect, for example, *hito*, one word meaning "person," is often pronounced *shito*.

Japanese has no alphabet, and though transcription into Roman letters (called *romaji*) is possible, this is neither popular nor widely used. To be precise, the language when written uses a combination of ideographs (*kanji*) and syllabaries (*kana*), the ideographs being a selection of those long used in China. Since Chinese pronunciation differs from Japanese, the ideographs were first given a (usually) one-syllable pronunciation as close to the Chinese as possible; later the meanings of characters were matched with their pronunciations in the spoken language.

Of the two syllabaries, *hiragana* was developed a little earlier in the ninth century than *katakana*. Both were derived by simplifying Chinese ideographs. Today, *katakana* is used primarily for the transcription of foreign words, including a great number of loanwords from Western languages but excepting words from Chinese.

Hiragana appears when it is necessary to give a particular pronunciation to a Chinese character, when words are inflected, when grammatical connectors are required in a sentence, and when there is no *kanji*. It is sometimes used alone, as in books for young children and, of course, in readers for those learning Japanese as a second language. In either case, *kanji* are gradually introduced at an early stage.

What is considered the standard dictionary of Chinese characters contains 46,210 of them. To the relief of many, the number currently approved for daily use has been reduced to 1,850, plus a couple of hundred or so necessary to read names. The relationship between *kanji* and the *kana* syllabaries (each having 46 basic "characters") can be said to be two-fold: *kana* pin down the pronunciation; *kanji* indicate the meaning, a vital function since many words happen to be homonyms. *Hashi*, when spoken for example, means "bridge," "extremity," "beak" or "chopsticks," but the *kanji* for each is quite different. Without *kanji*, only context indicates the meaning intended.

As written communication, Japanese is complicated and, some Japanese have said, cumbersome. As a spoken language, however, it is manageable, at least on the pronunciation and grammatical levels. But as one might expect, proper spoken Japanese is complicated by the many variations and a profusion of agreed-upon nuances that are all but unteachable. Some Japanese say that no foreigner can ever really master the myriad subtleties. They may be right.

Use depends, for one thing, on the social position of the speaker in relation to the listener. But the matter is further complicated in that male language and female language are frequently quite different. What all this means is that to a person speaking proper Japanese the social nexus must be both properly assessed and expressed. After that, there are many permutations and combinations, of many shapes and colors.

 GOVERNMENT

Before the Meiji Restoration in 1868, Japan's government was a feudal system of great bureaucratic complexity, with legal and land-tenure codes, repeatedly modified, going back twelve centuries. Local authorities owed fealty to the daimyo, who were controlled by the *bakufu*, the central Tokugawa government in Edo, at the head of which was the shogun. Upon the restoration of imperial power, however, the emperor was reinvested with authority, and his prerogative was considered sacrosanct. The Meiji Constitution (1889) centered on this authority, which, in practice, meant also that of his court and his ministers.

With Japan's surrender in World War II, all this was changed. Under the new Constitution of November 3, 1946, sovereign power was officially transferred to the people. While the emperor was retained as a symbol of the state, he was at the same time divested of all his prior power and was denied the right to engage in political activities. A new bicameral National Diet was created, along with a parliamentary cabinet and a more extensive system of local autonomy. This charter also renounced war and guaranteed basic human rights and universal adult suffrage.

Under the new system, parliamentary procedures resemble those of European democracies rather than the congressional system of the United States. Party discipline is strong, major bills are usually introduced by the cabinet, and cabinet members face interpellation on the floor of the Diet. In principle, both houses must approve all legislative measures, including the ratification of treaties and the national budget, but if agreement is not reached, the opinion of the House of Representatives takes precedence.

With its elected lower house and appointed upper house, the prewar Diet was more like its British counterpart than is the present one. Both houses are now elective, and their power is counterbalanced by the right of the cabinet to dissolve the House of Representatives (councillors serve a six-year term) and the right of the Supreme Court to rule on laws suspected of violating the Constitution. The prime minister, who appoints the cabinet, is elected by the lower house from among its own members.

Except for the brief rule of the Socialist Party in 1947–8, postwar politics has been dominated by the rule of conservative parties, especially the Liberal Democratic Party (LDP), which held the seat of government for almost four decades following its formation in 1955. In 1993, after a series of scandals involving the LDP, a coalition of opposition parties and breakaway members from the ruling party formed the first non-LDP government in 38 years.

At the local level, in contrast to prewar days when administration was directed by the Department of Home Affairs, there is now a measure of autonomy, exercised through elected assemblies in the forty-four prefectures and three urban prefectures (Tokyo, Osaka and Kyoto). Other cities, towns and villages also have their assemblies, mayors and headmen. These local bodies are empowered to create, amend or withdraw certain types of ordinances, and residents of any division may demand action, including the dismissal of an official, by presenting a petition signed by one-fiftieth of the residents of the district. The modernization of Japan has certainly included the political process, and Japanese-style democracy is very much alive.

 # RELIGION

When a Japanese is born, the local Shinto shrine is usually notified; when a Japanese dies, a priest from a Buddhist temple often officiates. Between these two events there are many occasions when these parallel religions are consulted; marriages and the celebrations for children three, five and seven years old are observed with Shinto ceremonies, yet there are other important celebrations and events of a purely Buddhist nature.

Most Japanese thus practice two religions, a parallelism that is a unique feature of this country. Statistics bear this out. There are slightly over 83 million Shinto adherents but also nearly 80 million Buddhists. Since the total population is only 120 million, it is apparent that a majority practice a sort of double worship.

If two religions, in some ways antithetical, can be practiced simultaneously, how deep then is either belief? But to phrase the question in this way is to create a difficulty not recognized by the Japanese themselves.

Perhaps the best way to understand this is to look first at Shinto, the indigenous belief of the country. Practiced for over two thousand years, it is a non-exclusive religion, had no founder, and has no doctrines nor texts. The *kami* (for which we have no translation except "deity") are very numerous, and the name is applied impartially to mountains, big trees, large rocks, as well as to emperors, ancestors and military heroes. The *kami* seem almost designations rather than attributes, and there is nothing in them of the transcendent deities of Western religions.

Neither is there any sense of sin or guilt, so essential to other religions. *Tsumi*, the only Japanese word that could mean "sin," refers not to moral transgression but to ritual pollution (caused by death, disease, childbirth), which is cleansed by rites of purification. Even now, when visiting a shrine, one cleanses one's hands and mouth at the entrance, a symbolic gesture freeing one of pollution. The *kami* otherwise quite accept human nature as it is. The religion offers no code of conduct other than this implicit indentification between physical and spiritual purity and goodness.

Open, exoteric and affirmative, Shinto in its original state (discounting the now defunct State Shinto of prewar and wartime Japan) has fostered both a unique feeling for nature and a religious self-reliance so strong that it has allowed and even encouraged other forms of worship.

The other major religion in Japan (there are many minor ones, including Christianity, the adherents to which do not amount to even one million) is Buddhism. As a system of beliefs, Buddhism in all its various forms holds that enlightenment is possible. The Buddha taught that life is painful, that this pain is caused by desire, and that desire is a result of believing in the visible world and in one's own aspirations. The answer, therefore, lies in transcending earthly fetters by denying the illusions of the world and affirming the universal. This system of thought and ethics is fundamentally different from the accepting and nonphilosophical Shinto. Yet, at the same time, it too is built upon an observation of principles that can only be called natural.

Shinto may well have taught, say, the beauty of the cherry blossom, but it was Buddhism which indicated that its true beauty is its impermanence, that the scattering of the petals is the moment of truth as well as beauty, for here is to be observed the evanescence which we, as natural beings, also share.

In this sense then, the two religions can be thought of as complimentary, and it is for this reason that both shrine and temple are, with an apparent sincerity, visited as the occasion demands.

 EDUCATION

Before Japan's rapid modernization in the nineteenth century, the educational system was not very different from that of any feudal nation, and only a relatively small percentage of the populace received schooling. The privileged were taught literary and military arts and Neo-Confucian learning, while the less privileged studied, mainly, reading, writing and the abacus.

Among the many reforms ushered in by the Meiji Restoration of 1868 were those in education. In 1872 a new educational system was formed, free elementary schooling for both sexes was made compulsory in 1900, and by the early part of this century Japan was well on its way to becoming the most literate nation in the world.

In 1947, the educational system was again reformed, this time under the auspices of the Allied Occupation authorities, with the result that considerably more students began to acquire higher education and coeducation became increasingly common.

One of the primary changes was structural. Elementary school became a six-year course, followed by three years of junior high school, both of which are compulsory. Then comes an elective three years of senior high school, either for vocational training or in preparation for college entrance. Currently, about 90 percent of the students go on to senior high school, and a little over 30 percent to university. In preparation for the long educational road, there is a growing number of kindergartens and nursery schools, some of which accept students from the age of three.

Much of the earlier schooling is centered around understanding, reading and writing the Japanese language, but at the same time more teaching hours are devoted to the arts, including music, and physical education than in any other major country. From junior high school on, extracurricular club activities from supplementary English study to the martial arts become an important part of a student's life, and of the teachers' as well, who spend a considerable amount of time acting as advisors, forming a much closer bond between students and teachers than is common in other countries.

Textbooks for the first nine years of schooling are provided free at the government's expense, but these, contrary to prewar practice, are not compiled by the government. Rather, they are written by private companies and then approved by the Ministry of Education on the basis of recommendations made by a council of teachers and others experienced in education, a process which has resulted in some criticism.

The Japanese have a literacy rate of nearly 100 percent, and the level of universal education is extremely high. The Japanese student is certainly more knowledgeable than his peers in most other countries. Whether the rote learning favored by the educational system results in understanding is, however, another matter—one which has led to some discussion. Critics say that the Japanese system places emphasis on mere knowledgeability in order to encourage the student, and eventually worker, to blend more easily into the group, but fails to promote the understanding necessary to develop individuality.

Besides formal education, there are long apprenticeships, originating perhaps in the guilds of feudal times, in any number of trades. To become a cook, for example, takes a minimum of two years of required training, but it is usually ten years before a person can become a chief cook or set up independently. And lifelong education is practiced on a scale found in no other country, by workers and housewives, teachers and executives, indeed by most of the country.

In Japan, more than in most countries, education counts. Good jobs depend upon good schools and knowledgeability remains a mark of culture.

ECONOMY

Japan as a capitalist nation had its beginnings in the early years of the Meiji period (1868-1912), when a free-enterprise economy replaced the earlier feudal system of production and distribution. The government took the initiative by sending numerous groups abroad to study technology as well as arts, sciences, and languages, and by providing the capital and management necessary for the establishment of modern industry. It was not long, however, before nearly all industries were sold to private management groups known as *zaibatsu*, which diversified their capital and managed a variety of producing and distributing enterprises. Since their aims did not conflict with those of the government, which were to raise the standard of living and to place Japan on an equal footing with other nations, they remained powerful until the end of World War II.

With cotton-spinning and other light industries in the forefront, basic industries were established one after another. Between 1914 and 1918, industrial production quadrupled, and by the 1930s Japan had achieved a modest position in the world's economy.

Among the sweeping economic reforms of the Allied Occupation forces after the war were the official dissolution of the *zaibatsu* and a program of land redistribution. The former left a great hole in the capital market, while the latter transferred land ownership from absentee landlords to the farmers themselves. Attention was then given to mechanization and the introduction of modern methods of agriculture. But despite government encouragement of diversification of crops, rice remains the principal product.

The 1960s witnessed enormous economic development, despite shortcomings in the domestic supply of raw materials. The world was then turning from coal to oil as a basic energy source, and Japan had no oil to speak of. The coal mines either had reached a state of exhaustion, or yielded only low-grade coal. Japan lacked many other minerals and metals, which had to be imported to supplement domestic supplies.

Nevertheless, during the 60s the national income expanded at an annual rate of about 10 percent, and personal income and living standards more than doubled, so that today they are on a par with those of Western European countries. This was made possible by extensive and flexible planning, the use of nearly 30 percent of the national income for capital investment, and the near doubling of labor productivity. Contributing to the latter were the introduction of new technology and a wide-scale refurbishing of both plant and equipment. By the early 1970s, Japan was high within the top ranks in world industrial production.

The Japanese economy is greatly dependent on international trade. This has led to grave international complications as Japan's trade imbalance with many Western nations, in particular the United States, has continued to grow. Japan is perceived as an opportunistic nation which does not abide by the "fair trade" principles which the debtor nations insist upon. In turn Japan, in seeking to protect its own markets, counters that the West has failed to understand the unique nature of the Japanese consumer and has as a consequence "failed" to penetrate the Japan market.

The dialogue continues, threatening at times to escalate into argument. Japan's necessity for international trade is a strength in the enormous production of the country's economy. At the same time it may be perceived as an enormous weakness since without it the country cannot even feed itself. Complicating this is a Japanese attitude which continues to see economic growth as a panacea.

 # THE JAPANESE HOUSE

Traditional Japanese domestic architecture has had widespread influence on contemporary architects in other countries. Indeed, international modern architecture owes much to the Japanese example. From the early *shinden-zukuri* through the later *shoin-zukuri* styles, Japanese architecture has incorporated functional simplicity in its design, the complete opposite from such Western architectural concepts as the façade. Moreover, Japanese architecture was the first to make use of modules, a practice now common in all contemporary building.

One still sees both principles in the modern Japanese room. All supports are visible and all units are modular. The sliding inside doors, or *fusuma*, and the paper-covered lattice doors, or *shoji*, are standard in size (which varies slightly from district to district). *Shoji* are traditionally outside doors but are now also used between rooms, glass having taken the place of paper in the outside doors, another reminder that the old can always be modified. The straw-covered reed mats, or *tatami*, where one sits on *zabuton* (cushions) or sleeps on *futon* (pallets), are also of standard sizes, and the size of the various rooms of the house is always indicated by the number of mats. Even doors, windows and closets are measured in terms of the size of *tatami*, so the carpenter and the *tatami, shoji* and *fusuma* makers are always working with identical dimensions. This allows for ease of construction, once the overall size of the house has been decided, and a uniformity of appearance pleasing to traditional Japan.

This said, it must be added that though the newly built Japanese house used to have but one Western-style room, it now has but one Japanese-style, if that.

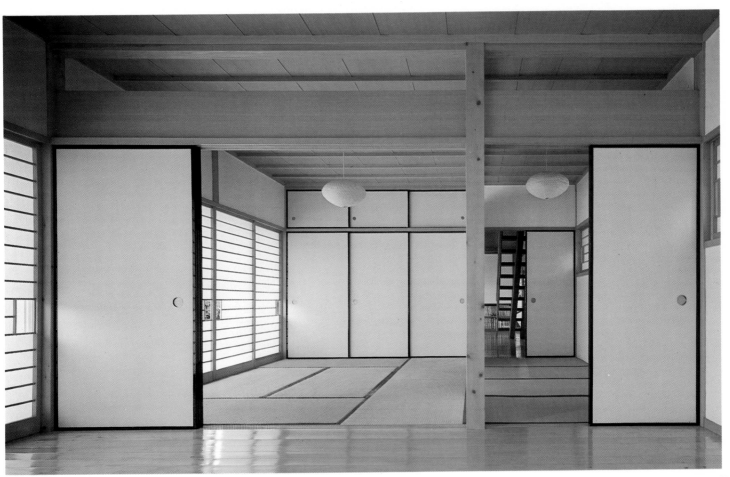

 # CUISINE

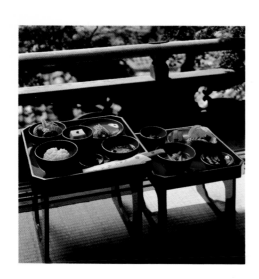

Rice is to the Japanese cuisine somewhat as the potato is to the Western. It is ubiquitous and always appears no matter what.

Indeed, there is a small mystique surrounding this staple. When it is served with purely Japanese food, it is called the honorific *gohan*; with a Western or a Chinese meal, however, it is simply called *raisu*. The mystique continues in that the grain itself should be native to Japan, the rice of certain districts being more highly prized than that of others, and must be cooked in the special manner that insures each grain's being both separate and tasty. A part of the mystique may come from the long association of rice with the Shinto religion—certainly something must account for rice being not only overproduced but also costing more than fifteen times as much as it does in other lands. Perhaps the main reason for the special reverence is that Japan was for so many centuries a relatively poor country. As always, turning a liability into a virtue, the Japanese assured their only major food an importance and a beauty (white rice set off in a black lacquer bowl is an aesthetic treat) perhaps not inherent in the grain itself.

Appearance certainly accounts for much of the pleasure to be derived from the cuisine, whether one is Japanese or foreign. How a thing looks is no less important than how it tastes, and many are the intricate ways of cutting, arranging, serving, so that the eye will be as satisfied as the stomach. The epitome of this art is seen in *kaiseki ryori* (*top left*), which sometimes accompanies the tea ceremony and has been termed the cuisine of Zen. Given such factors, the Japanese meal, even the simplest, takes on an aspect more ceremonial than is ordinary in the West. Paralleling *kaiseki ryori*, the most usual domestic meal will start with a clear soup (*suimono*) and end with pickled vegetables (*tsukemono*).

In between are the various courses: the succulent raw fish (*sashimi*), raw fish atop vinegared rice (*sushi*), eels (*unagi*), all kinds of fish cooked and served perfectly, and the very popular *tempura*—delicately-fried shrimp, fish, squid, vegetables (*middle*). There are also numerous varieties of *nabemono*, stewlike affairs usually cooked at the table. Among these the most popular, and the one the foreigner is certain to know and love, is *sukiyaki*, a very attractive dish of beef simmered in soy sauce, stock and sake, along with leeks, Chinese cabbage, tofu and, perhaps, chrysanthemum leaves (*bottom*). Each mouthful is dipped into raw egg seasoned with soy sauce, and the whole is eaten, naturally, with bowls of white rice.

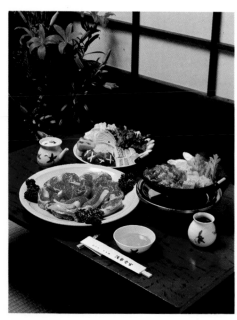

In addition, and in place of rice, there are *soba*, *udon* and the popular *ramen* (all varieties of noodles), and then there are the seasonal and the regional dishes—the soup (*ozoni*) and rice cakes (*mochi*) of New Year's, crab from Hokkaido and sweet potatoes from Kyushu—with many delicate shadings and discriminations. From Tohoku comes the best of the *nabemono*, but Kyoto, whose cuisine is considered the most delicate of all, offers its succulent chicken and mushroom *mizutaki*.

As will be evident, among all of the fast-vanishing traditional aspects of the lifestyle, it is the Japanese cuisine that remains most as it was. In this important and basic way, Japan continues to retain elements of its past.

CRAFTS

The traditional crafts of Japan are, like those of any country, firmly rooted both in nature and the lives of the people. Unlike many peoples, however, the Japanese make no division between arts and crafts, each blending into the other and being informed by the same sensitivity. There are hundreds of different kinds of crafted objects and scores of long craft traditions. These include almost everything used in traditional Japanese life.

For the summer, for example, there are *ogi*, folding fans (*top left*), made with delicacy and precision in the most refined taste. There is the art of dyeing, centered in Kyoto, and still practiced in the old way. When, as with this craft (*bottom right*), the master craftsmen are few, they are registered by the Japanese government as "Possessors of Intangible Cultural Properties" and are correspondingly honored. There is also the major art of Japanese joinery, which creates not only the architecture but also the furnishings of the house, objects such as *tansu* (chests), superbly crafted (in this case, of *keyaki* or zelkova wood) and of a sturdily functional elegance.

These twin principles that govern Japanese crafts — a functional design and a respect for the materials — are always discernible in two crafts with the longest lineage: lacquer ware and ceramics. Lacquer work began very early, around the eleventh century or before, and the originally Chinese inspiration became purely Japanese. A laborious process (the finished pieces require many coats of lacquer to be thoroughly polished after each has dried), it creates an object, most commonly nowadays a bowl, dish or tray, of immaculate beauty.

Japanese ceramics, of which there are dozens of varieties, were made as early as the eighth century, but the craft did not become a major one until Chinese methods were introduced in the thirteenth century. During the Edo period, Japanese ceramicists fully digested the earlier Chinese and Korean influences and almost every province came to have its own ware — Arita from Saga, Kyo from Kyoto and (*left*) Kutani from Ishikawa.

There is in this century something of a renaissance in Japanese ceramics. Particularly after World War II, a new impetus has been seen in the old kiln districts such as Mashiko in Tochigi Prefecture, Karatsu in Kyushu and Hagi on the Japan Sea. A new public for these traditional wares has appeared, and a number of fine ceramic artists have come to international attention. Still very much alive, this ancient craft now displays in its most perfect form the Japanese awareness of proper functional design and a supreme knowledge of materials.

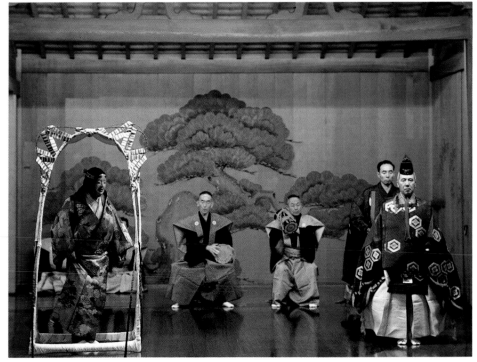

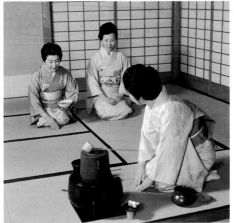

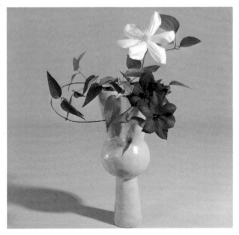

A number of the arts thought of as being most typically Japanese evolved during the fifteenth century, many of them under the patronage of the shoguns, and particularly under Yoshimasa (1436–90), the eighth of the Ashikaga shoguns. Both he and his ancestor Yoshimitsu were patrons of the austere, classical No drama, which was perfected by the playwright and actor Zeami (1363–1443). This severe, static and solemn form of theater, using neither scenery nor props except for simple symbolic structures, combines music, verse and prose to create, through extreme simplicity, a cogent observation on the beauty and evanescence of life. During performances (*above*), with hieratic movements and a masked main actor, these noble plays are capable of affecting the emotions in so profound a manner that Western analogies to the ancient Greek drama do not seem overstated.

Its aesthetic profundities are shared by, among other arts, *ikebana* (flower arranging) and *chanoyu* (the tea ceremony), which were codified about the same time and which have both become typical vehicles of Japanese sensibility. Both are also about much more than simply putting flowers in a vase or merely drinking tea. Specifically, they are concerned with creating an inner accord with the world of men—the small universe, as it is sometimes called. The contemplation necessary for both creation and appreciation involves a degree of awareness and emotional subtlety now rare but apparently more common in former times. It was in the tea room of Yoshimasa's Silver Pavilion in Kyoto that these arts were perfected and celebrated by the military ruler and his circle of aesthetes.

One small indication of this abiding appreciation is the simpler but painstaking art of the *bonsai*, in which miniature trees, like visible *haiku*, capture the beauties of nature as a whole. Here, nature, celebrated in the No, made visible in *ikebana*, and forming the basis of the meditative *chanoyu*, is humanized in small metaphors of itself.

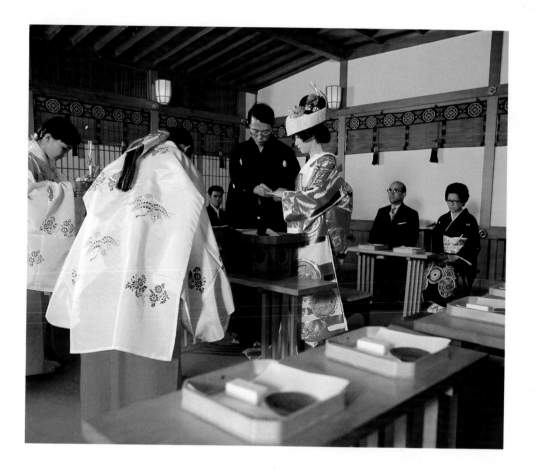

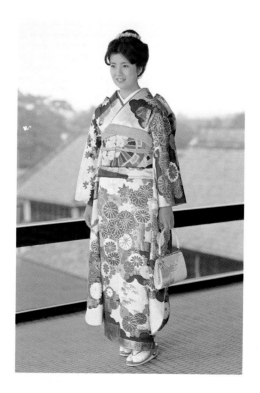

The traditional Japanese dress is the kimono, a term that has come to mean any kind of Japanese clothing but specifically refers to an ankle-length garment held in place by the sashlike obi and having long, loose sleeves. Though kimono styles have often changed over the centuries, the basic form has survived from the earliest times to the present.

Women's kimono differ from men's with their longer length (the excess folded over and held by the *obi*), and fuller and longer sleeves. The way of folding one side of the garment over the other is also different. While men's kimono tend to the somber in pattern and color, women's are extremely varied. It is possible for experts to tell a woman's age and social status from her kimono. Another difference is that it is mainly kimonoed women one sees on the street. Men in kimono, except for those wearing the informal *yukata* or *tanzen* (summer and winter) robes around the house, are rare indeed, and seldom seen except at such formal occasions as weddings (*above*), funerals and the New Year's holidays.

Though Western dress is overwhelmingly more popular among both sexes, the tendency to isolate things Japanese from things foreign is observed; the only Western elements tolerated with the kimono are the wristwatch and, for women, Western-style makeup. Similarly, the kimono is more often worn for purely Japanese events: the tea ceremony, the flower viewing, the lesson in traditional music or dance, or its performance, and such typical and formal occasions as the initial meeting of the prospective couple in an arranged marriage. Along with the kimono and *obi* are worn the proper accoutrements, the socklike *tabi*, and *zori* (sandals) or *geta* (clogs).

MARTIAL ARTS

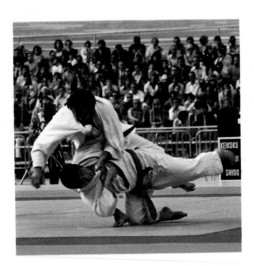

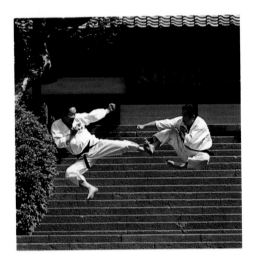

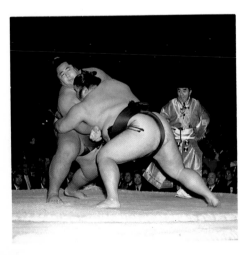

The martial arts of Japan, collectively called *budo*, are comprised of most of the sports which have evolved during the country's long history.

Sumo (*lower left*) is the most visible of the *budo*, since the thirty or so highest ranking professionals compete in six annual fifteen-day tournaments and these, carried live on radio and television, are widely followed. A form of wrestling dating back to hand-to-hand combat techniques of nearly twenty centuries ago, the idea is that one of the *sumotori* throws his opponent or forces him out of the ring. Though it sounds simple, it is not. There are more than seventy techniques, as well as many rituals and many ceremonial details of Shinto origin, that make it one of the grandest sport shows of the country.

Three of the martial arts are well known abroad: judo, aikido and karatedo. In judo (*upper left*), there are three phases of training: *kata*, standard forms practiced over and over for as long as one practices judo; *randori*, a free-style exercise in which techniques are applied; and matches, in which points are given for throwing the opponent, pinning him or gaining his submission by neck-holds or armlocks. There are many ways, all codified, of doing these. Judo is a Meiji-period (1868–1912) modernization of Edo-period fighting techniques.

Aikido, whose origins go back to the eleventh century, shares one principle with judo, that of turning the power and direction of the opponent's attack to one's own advantage. It also has throwing techniques and holds, the latter based entirely on bending or twisting the opponent's arm or leg and applying what are called pain-holds. It is especially well known for developing the ability of a man or woman to thwart the attack of a much larger person, in which respect speed and decisiveness are most important.

Speed and decisiveness are also the objectives of training in karatedo (*middle left*), which derives from very closely guarded-techniques developed in Okinawa and not publicly introduced to the rest of Japan until 1922. It too has *kata*—elaborate but performed gracefully and very rapidly—and these are based on blocking, striking and kicking, so that it resembles boxing more than wrestling. The only weapons are hands, arms, legs and feet, but these are so powerful, after long training, that actually making contact with one of the vital points of the human body can be lethal.

Students of the martial arts—and there are hundreds of thousands of them—are urged to develop physical soundness, agility, coordination and, above all else, good judgment and sound character. These are also the objectives of practicing *kendo*, the way of the sword, which goes back to the twelfth-century Kamakura period.

When the samurai class was dissolved during the Meiji period, kendo came to employ a specially-designed bamboo stave, along with face guards and breastplates. Principles did not change much, however, the objective being to hit three parts of the body—the head, the torso and the wrist—and climax with a mock throat jabbing. What is valued, as in the other martial arts, is the concentration of power at the proper instant, which requires perfect management of the body and lightning speed.

Kendo, with its "sudden death," its legends and secrets—and masters refusing to pass these on to the unworthy—is the essence of the martial arts. Perhaps by honing to a high level some skills that apparently are never to be used, practitioners reveal an aspect of the national character.

Iro ha, traditionally used as a way of learning to write, gives the pro-
nunciation of all the basic characters in the *kana* syllabaries, without
repeating any pronunciation. It appears opposite in typeset *kanji* and
hiragana; above in calligraphic *kanji* and *hiragana*.